IMAGES
of America

LEMON GROVE

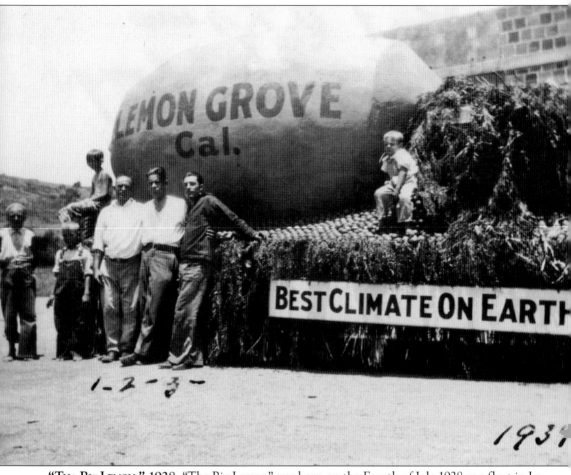

"THE BIG LEMON," 1928. "The Big Lemon" was born on the Fourth of July 1928 as a float in La Fiesta de San Diego parade. Designed by Alberto Treganza and built by local ranchers, the float carried the first Miss Lemon Grove, Amorita Treganza, and her six princesses—Florence Close, Eloise Jensen, Arleen Moore, Helen Smith, Ione Tooker, and Adalaida Treganza. The civic slogan, "Best Climate on Earth," was coined by Anthony "Tony" F. Sonka in 1925 and has remained part of "The Big Lemon" since 1928.

ON THE COVER: "THE BIG LEMON", OCTOBER 3, 1957. Tony Sonka, flanked by Lemon Grove Business Women's Club members Julia Farley, Mabel Carlton, Kay Anderson, and Ada Constant, presided over the flag raising at the lemon after it had been moved slightly to accommodate railroad repairs. Credited with jump-starting the town's post-agricultural economy, Sonka was the heir to A. Sonka and Son General Merchandise at Main and Pacific Streets and an influential figure countywide. (Courtesy Lemon Grove Historical Society.)

IMAGES
of America

LEMON GROVE

Helen M. Ofield and Pete Smith
Lemon Grove Historical Society

ARCADIA
PUBLISHING

Published by Arcadia Publishing
Charleston SC, Chicago IL, Portsmouth NH, San Francisco CA

Printed in the United States of America

Library of Congress Control Number: 2009928048

For all general information contact Arcadia Publishing at:
Telephone 843-853-2070
Fax 843-853-0044
E-mail sales@arcadiapublishing.com
For customer service and orders:
Toll-Free 1-888-313-2665

Visit us on the Internet at www.arcadiapublishing.com

*Dedicated to the memory of Agnes Osgood, the founder
and first historian of the Lemon Grove Historical Society,
and Donald Heyser, the second historian, in gratitude for
their careful research and vivid eyewitness accounts.*

CONTENTS

Acknowledgments

The Lemon Grove Historical Society is our city's attic. The stories, folklore, and facts about people and events, from antiquity to the modern age, that comprise this unique community are stored in the literal attic of the society's Parsonage Museum (1897) and in its cultural center, the H. Lee House (1928). Both buildings bear the dream of the founders of the historical society who yearned for a permanent home to display our shared history and the work of the artists and thinkers in our midst.

We thank the founders of the Lemon Grove Historical Society and the 246 charter members who shared their vision in 1978. Many of them contributed important materials to the fledgling archives.

There would be no museum without the brilliant duo of Bob and Mary Martin and the labor and expertise of Ernest Strzelecki, Bob Holaday, Gary Elbert, Dona Lynn Clabby, the late Donald and Shirley Pountney, the late Gloria McKeen, and teams of AmeriCorps members. Nor would there be a Lemon Grove History Mural depicting our civic story without our inspired artists-in-residence, Kathleen Strzelecki and Janne LaValle. We thank the past and present board members of the historical society for their leadership as well as the current board secretary, Josie Kane, for her insightful readings of the draft manuscript for this book. Thanks also go to Patricia Jones for reading the draft text and to the staff of the City of Lemon Grove and many community members for sharing photographs and memories. We thank Sharon Konz for research assistance, and Margaret Southwick, the late Arleen Moore Dodson, and other museum docents who sorted archival items. Profound thanks go to District 2 County supervisor Dianne Jacob and the Lemon Grove City Council for their support of our efforts to save local history. Our late mayor Dr. Robert F. Burns and our 14-year councilmember, Thomas E. Clabby, are standouts for their service to historic preservation.

Appreciation goes to the editors at Arcadia Publishing for their guidance and encouragement.

To everyone who ever visited a local museum and came away saying, "Now I know more about my own community," your capacity for lifelong learning forms a benediction on civic life.

Finally, we thank our life partners, Jack Ofield and Cherie Smith, for bearing with us at the midnight hour as this book wended its way to completion.

(Note: Unless otherwise credited, all photographs are from the Lemon Grove Historical Society's archives.)

INTRODUCTION

Lemon Grove arose, literally, from the primeval ooze. Over the millennia, plate tectonic shifts below the earth's mantle caused the movement of land masses, including the future Lemon Grove, northward from the area of Sonora, Mexico, toward the polar cap. The fossil record, dating from the Eocene epoch 40 to 45 million years ago, in both Northern Mexico and Southern California, shows that similar species inhabited the vast primordial sea that covered the entire area. Fossils of those vanished creatures continue to be discovered today.

The region of Lemon Grove was first inhabited in the late Stone Age, about 10,000 BCE, by the San Dieguito Complex people. They lived in small groups and were primarily hunter-gatherers. About 1,500 to 1,200 BCE, a new Yuman-speaking group, who called themselves the Kumeyaay (or *kumiai*, meaning "the people of the earth"), arrived in the region from the Colorado River Basin. They were later called the Diegueño culture by the Spanish conquerors.

The confrontation between this Stone Age society and the Iron Age Spanish was catastrophic. The Kumeyaay were decimated by disease, loss of customs and subsistence, and displacement from ancestral lands. Yet the Kumeyaay endured into the 19th and 20th centuries and, with Anglo-European, Japanese, and Latino peoples, helped to build modern Lemon Grove.

In 1769, the area that became Lemon Grove was part of Mission San Diego de Alcalá—the mission lands colonized by Spain for the purpose of developing trade and spreading Catholicism. When Mexico gained independence from Spain in 1821, residents of Alta California, known as Californios, farmed and ranched on huge land grants. Many land grants were given to soldiers in lieu of salaries or to those who gained political favor. One landholder, Santiago Argüello, was awarded more than 59,000 acres.

Lemon Grove's progenitor, Robert Allison, arrived in 1850 to Sacramento, where he ran a hotel for gold miners. In 1869, he purchased thousands of acres of land from the heirs of Santiago Argüello—land that would become Lemon Grove, La Mesa, Encanto, and part of Spring Valley. In 1886, he became a director and stockholder of the San Diego and Cuyamaca Railroad and built the Allison Flume. Both rail transport and water were critical to the success of the future lemon groves.

In 1892, Allison's son, Joseph, filed subdivision maps for the town site known as "Lemon Grove," a name probably coined by his mother, Tempa Waterman Allison. Parcels of land were sold, and citrus groves were planted. The gentle climate and constant mild breeze were ideal for growing all types of subtropical fruits as well as vegetables.

Gentlemen farmers from the East and Midwest looking to farm in a flawless climate formed the Lemon Grove Fruit Growers Association in 1893. By 1894, the *San Diego Union* called Lemon Grove "a sea of lemon trees." In 1922, reporter C. A. McGrew called it "one of the most attractive communities in the county . . . lemons, oranges, grapefruit and similar fruits . . . have received medals for excellence." The railroad carried millions of tons of fruit across the growing nation. Ranchers built handsome homes, established a community, and launched the onward rush into the 20th century.

Central to the growth of modern Lemon Grove was the Sonka clan. In a classic immigrant success story, the brothers, Joseph and Anton Sonka, fled the turmoils of Bohemia (today the Czech Republic) for America. They settled in Seguin, Texas, where they launched several businesses and ran a saloon. After a fraternal quarrel, Anton and his German American wife, Anna Klein Sonka, took their six children to San Diego. There they heard of a mercantile opportunity in Lemon Grove. They bought the general store and proceeded to boost the town's economy with a business that became the Walmart of its day. Everyone for miles around shopped at A. Sonka and Son. The eldest son, Anthony "Tony" F. Sonka, became a force in the region, but it was his support of a unique project that would give the town its major landmark: a humongous lemon perched by the railroad tracks.

Lemon Grove had long participated in parades in downtown San Diego to advertise its fruit; however, the 1928 Fourth of July La Fiesta de San Diego parade was different. Lemon Grove had just won the 1928 trophy for best fruit at the county fair. Main Street had just been paved for the first time. The four-year-old grammar school was booming. There were seven chicken ranches and five dairies. The town was growing. Life was good. Sonka, along with a committee of local ranchers, commissioned a gifted local architect, Alberto Treganza, to design an immense lemon that would make the ultimate statement about the town's purpose, prosperity, and optimism.

Led by Edmund Dunn, a British orchardist who settled in Lemon Grove in 1921, the ranchers built the lemon of plaster, wire, and wood and hoisted it onto a farm wagon. Weighing 3,000 pounds and aptly dubbed "The Big Lemon," the float won third prize in the parade and was towed home in triumph. Lemon Grovians loved their creation and refused to part with it. Tony Sonka shrewdly had it placed opposite the store's front door on Main Street, adjacent to the railroad tracks in the center of town. From that day on, but for occasional shifts to accommodate railroad repairs, "The Big Lemon" has stood there on its pedestal in perpetual sunshine. "Oh, fruity behemoth, live! *Citrus Medica*, symbol of a people that, for the life of them, just cannot think small, live!" went one paean to the icon when it won an Orchid in the Civic Folk Art category in San Diego's 1997 Annual Orchids and Onions Awards. "Oh, Big Lemon—hilarious, unabashed, exuberant—live!"

The Great Depression began to alter the town. In 1930, economic fears helped to kindle a segregation case involving Lemon Grove's lone grammar school and some 75 Mexican American pupils. The groundbreaking case was resolved within three months after a remarkable effort by the pupils' parents.

The impact of World War II on California, coupled with the postwar boom, inevitably triggered the passing of Lemon Grove's "sea of lemon trees," as orchards were transformed into housing developments and parklands. The town became a choice residential area with eight schools and diverse businesses, including the famed Grove Pastry Shop housed in the original Sonka Brothers Store.

After heated debate and four incorporation elections since the 1950s, Lemon Grove finally was incorporated on July 1, 1977. The little whistle-stop town became California's 414th city and the 14th city in San Diego County. Its first elected city council was installed in a city hall located in three rented rooms on Main Street.

Today the City of Lemon Grove thrives with some 25,000 residents; a five-member city council; a visionary redevelopment agency; hundreds of businesses; an award-winning school district; community, recreation, and senior centers; a busy historical society; service clubs; five parks; many churches; and neighborhoods still dotted with fruit trees. The hold out orchard, "The Old Dunn Orchard," run by the heirs of "The Big Lemon" builder, Edmund Dunn, recalls the agricultural heyday of Lemon Grove. The city proudly proclaims its history and sense of community amid the "Best Climate on Earth" as a progressive 21st century city. Oh, Lemon Grove, live!

One

LAND WILD AND TAMED

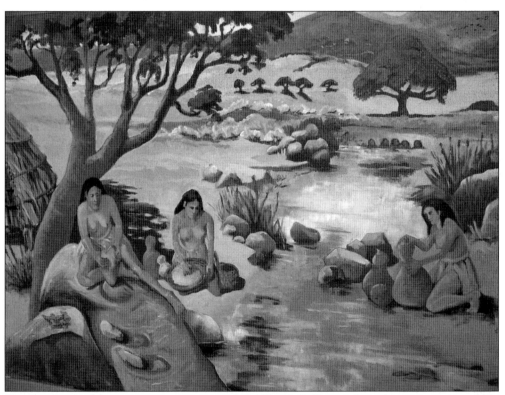

THE LA JOLLA CULTURE, 8,000–3,000 BCE. The La Jolla may have been ancestors of the present-day Kumeyaay Nation. The women depicted here are making food storage vessels from gourds, grinding acorns on a milling stone, and sifting acorn flour in a flat, porous basket. In this early prehistoric period, a river flowed through the future Lemon Grove to the river in modern-day Mission Valley. Area road excavations continue to yield artifacts, fossils, and other evidence of early cultures and environments in the vicinity of the ancient riverbeds. (Painted by Kathleen Strzelecki for the Parsonage Museum.)

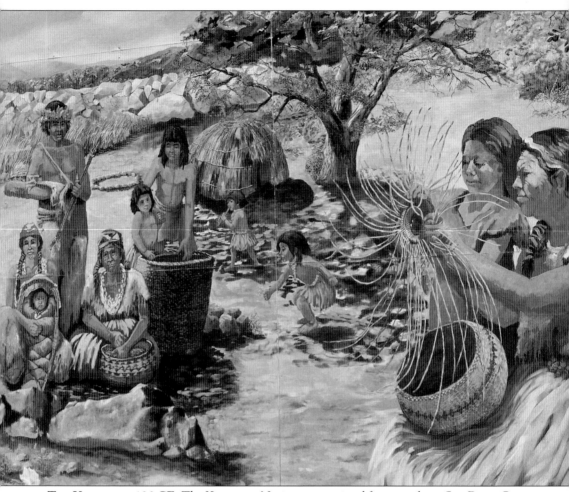

THE KUMEYAAY, 100 CE. The Kumeyaay Nation once existed from northern San Diego County south through Lemon Grove into northern Mexico and eastward into the Imperial Valley. Their self-sufficient society thrived in a period of regular rainfall. Clothing, shelter, weapons, and utensils were fashioned from animal skins, bark, branches, grasses, gourds, stone, and other materials. The Kumeyaay world comprises Panel I of the Lemon Grove History Mural—commissioned by the Lemon Grove Historical Society and painted by Janne LaValle and Kathleen Strzelecki—on the wall of the historic 1912 Mission Revival store at Main and Pacific Streets.

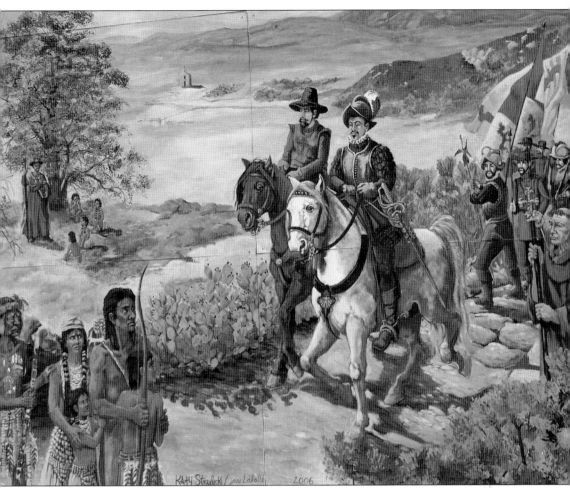

THE SPANISH CONQUEST, 1769–1821. The Spanish brought horses and cattle that devoured grasses and plants. Their system of ploughed, fenced farmlands and forced labor undermined Kumeyaay autonomy and self sufficiency. Lacking immunity to foreign diseases, they died in droves. Yet, from 1769 onward, Kumeyaay warriors were the most resistant of all California tribes to Spanish subjugation. Fewer than 100 had been converted to Catholicism by 1775—the year the Kumeyaay burned down Mission San Diego de Alcalá. Panel II of the Lemon Grove History Mural depicts an encounter between a Kumeyaay family and a Spanish troop.

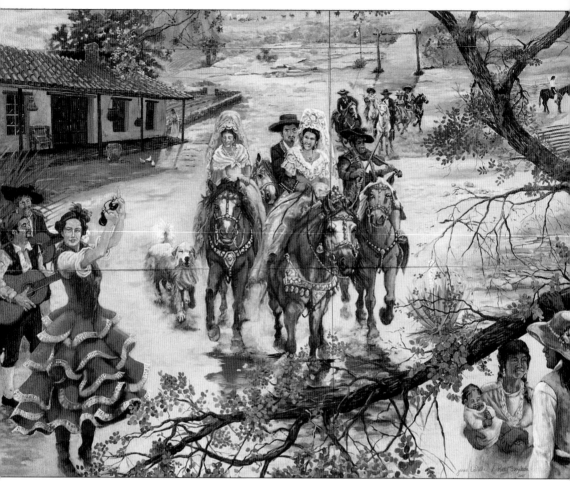

THE MEXICAN RANCHOS, 1821–1848. Mexico overthrew the Spanish crown in 1821, capturing the mission lands. The Kumeyaay became a source of cheap labor on huge land grants devoted to ranching and industry. They continued to resist enslavement by Mexican Californios but also adapted by becoming artisans, vaqueros, and housekeepers. Panel III of the Lemon Grove History Mural depicts a Mexican wedding party, a Kumeyaay housekeeper on the veranda, Kumeyaay vaqueros herding cattle, and a Kumeyaay family in the foreground. In a foreshadowing of changes to come, a distant line of prospectors heads for the gold fields.

SANTIAGO ARGÜELLO (1791–1862). Born in Monterey, California, the aristocratic, adroit Santiago Argüello served in both the Spanish and Mexican armies. He was granted the Tia Juana Rancho in 1829, the Trabujo Rancho in 1841, and, in 1846, the San Diego Mission lands, including those that became Lemon Grove. He aided U.S. forces during the Mexican-American War and was a captain in the California battalion. Later he became a collector at the Port of San Diego. He died intestate, prompting his numerous descendants to claim conflicting ownership rights. (Courtesy San Diego Historical Society.)

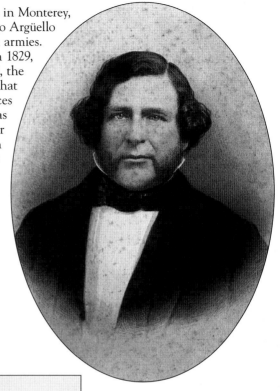

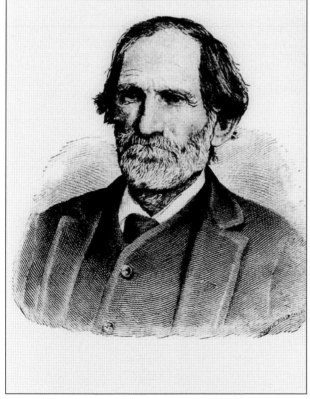

ROBERT ALLISON (1814–1891). In 1850, Robert Allison traveled by oxcart with his family from Iowa to California to open a hotel near the gold fields. He was successful in business despite failing health. In 1868, in search of a better climate for Robert, the Allisons arrived from their Vacaville ranch with 3,500 sheep to graze at La Mesa Springs. In 1869, they bought 3,000 acres of the Cuyamaca Grant and 8,000 acres of the Ex-Mission Rancho Grant from the heirs of Santiago Argüello. Later they launched the Allison Flume. (Courtesy La Mesa Historical Society.)

DEED.

Dated Feb. 2nd. 1889. 18

R. Allison.

Consideration, $ 1.

 TO

Covenants: Grant.

John Ginty, Trustee.

CONVEYS, situate in the

County of San Diego, State of California, Lot 12 of the Ex Mission

Grant as allotted to Robert Allison in the Partition suit of

Juan M. Luco et al plaintiffs vs the Commercial Bank of

San Diego et al ,defendants,containing 4252.20 acres,less

the following since sold by Robert Allison----

(Exceptions do not affect property herein abstracted)

Witness:

Signed:
R. Allison.

Acknowledged:

Feb. 2nd. 1889,

 in San Diego Co. .Cal.,

Before Monroe Johnson,Notary Public,
 , with official seal affixed.

Filed for Record Feb. 5th. 1889 18 , at 11 hours 5 min. A. m.

Recorded in Book 144 of Deeds, page 33. E. G. Haight.

Remarks: RECORDER.

ALLISON DEED, FEBRUARY 2, 1889. This court-ordered deed awarded Lot 12, encompassing 4,252.20 acres of the Ex-Mission Rancho, to Robert Allison. This land became Lemon Grove, La Mesa, Encanto, and part of Spring Valley. The deed resulted from a lawsuit brought by Juan M. Luco, contesting Allison's ownership of this portion of the Ex-Mission lands. Lawsuits were common after the break up of the Mexican ranchos with their confusing boundary lines. Allison's sons, Frank and Joseph, sold portions of Lot 12 to every pioneer grower in Lemon Grove.

14

Two

THE WHISTLE-STOP TOWN IS BORN

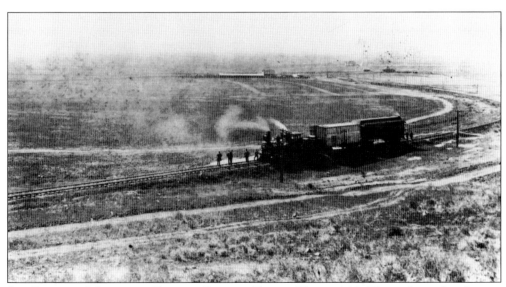

SAN DIEGO and CUYAMACA EASTERN RAILWAY ENGINE NO. 1, 1892. This is the earliest known photograph of Lemon Grove. The railroad reached the area in 1888. Here the train heads northeast toward La Mesa. In the background is Lemon Grove's tiny downtown. The most prominent building is the new citrus packinghouse. Trains were as essential as water to the town's pioneer growers, for without them, the citrus crops had no route to national markets.

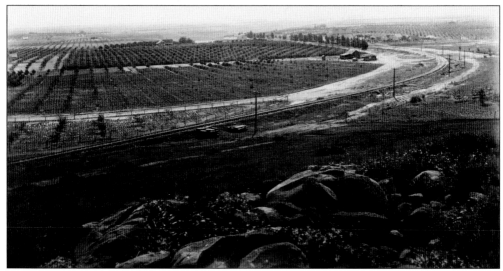

RAILROAD TRACKS AND ORCHARDS, C. 1895. This view looks south toward the curving sweep of railroad tracks leading into Lemon Grove with its abundant young orchards.

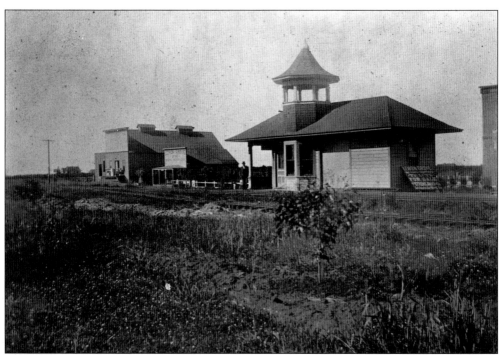

TRAIN DEPOT, 1895. The railroad depot stands by the tracks near the Lemon Grove Store and the fruit-packing shed (just north of modern Pacific Street). The sign leaning on the depot wall reads "Lemon Grove; Tracts for Sale; and Strong Arms & Co." The curve on the roof edges was called a "Chinese kick," a style popular in the period. The cupola was open to permit the depot agent to wave flags to oncoming trains to stop, proceed, or proceed with caution. The depot was removed about 1950 for road widening.

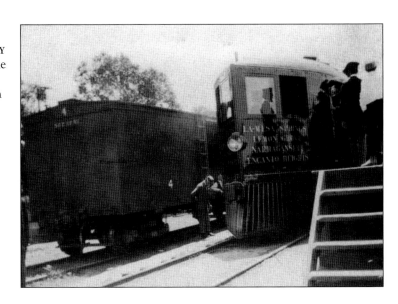

Train Arriving at Lemon Grove, Early 1900s. On the engine are the words "La Mesa Springs, Lemon Grove, Narragansett, Encanto Heights," a clear indication that the upstart towns were the wave of the future. In 1907, the new gas-powered passenger engines were dubbed "skunk trains" for their strong smell of gas.

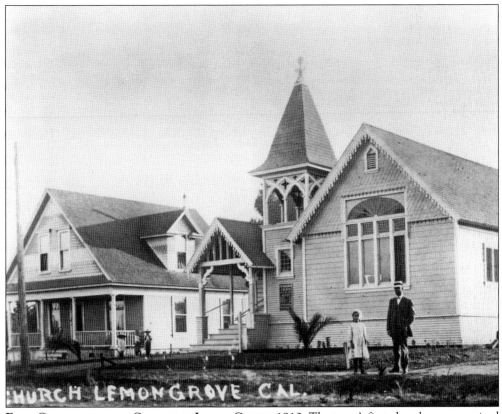

First Congregational Church of Lemon Grove, 1910. The town's first church was organized in 1894 by Rev. Isaac Atherton and built in 1897 for $975. The church stood at Main and Church Streets until it was moved a block west in 1912 to make way for a larger church. The building survives today, minus its steeple, as the Parsonage Museum of Lemon Grove, located at 3185 Olive Street.

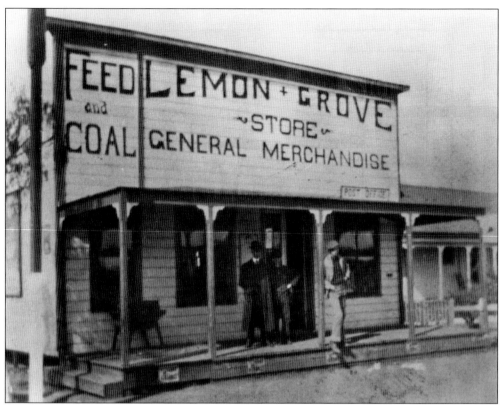

THE LEMON GROVE STORE, C. 1900. At Joseph Allison's urging, A. E. Christianson built the Lemon Grove Store in 1891 to fill ranching and domestic needs. He died in 1893, and Mortimer Bond from Long Island, New York, ran it for two years. The store contained the post office and was the community hub. When the train whistle sounded, people gathered at the store in anticipation of mail, shipments, and visitors.

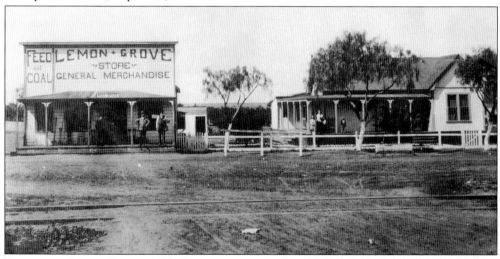

DOWNTOWN LEMON GROVE, 1903. German immigrant Joseph Kleinfield owned the Lemon Grove Store from 1895 to 1903. His wife and daughter stand on the veranda of their home next door to the store. A blacksmith forge once stood behind the store to shoe horses and mules.

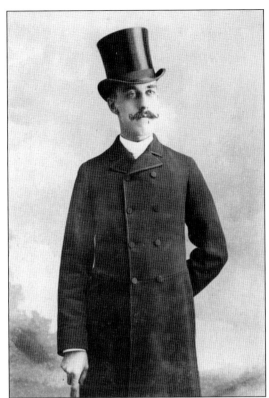

WILLIAM AND MARY ANN (DAVIS) TROXELL, 1885. William Troxell, 25, and Mary Ann Troxell, 24, are shown in their engagement portraits in Rockford, Illinois. In 1891, the Troxells came with William's younger brother, George, to start a new life as ranchers. They were typical, Midwestern, gentlemen farmers whose family money enabled them to invest in the California land boom. William was among the first growers in town, and his descendants believe that he named Lemon Grove.

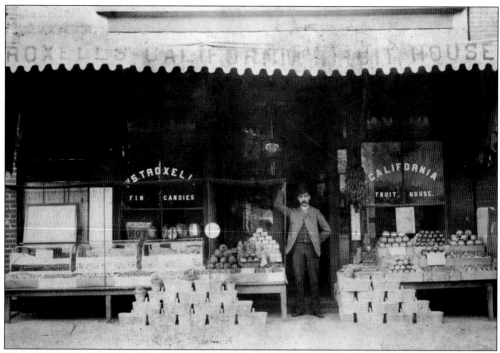

TROXELL'S CALIFORNIA FRUIT HOUSE, NOVEMBER 15, 1891. William Troxell stands in the doorway of his Rockford, Illinois, store. In 1890, he left his candy manufacturing business and went to Mexico. He visited Lemon Grove and purchased land from the Allisons, invested in their flume, and established a 15-acre citrus ranch. Strawberries were planted between rows of citrus trees. He began shipping fruit nationally and to his store, where his "fine candies" also were sold.

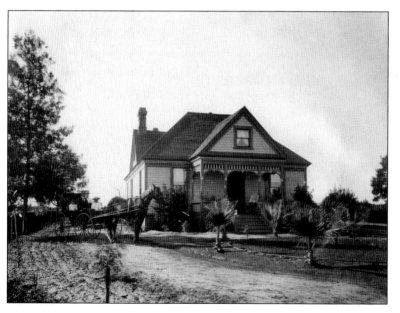

THE TROXELL MANOR, FEBRUARY 5, 1898. William and Mary Ann Troxell and their children sit in the carriage outside their hilltop home built in 1892 on Olive Street—the third house in Lemon Grove. The house survives, along with its century-old Moreton Bay fig trees.

GEORGE AND IDA TROXELL, 1890.
George Troxell, 23, and Ida Troxell, 21, are seen in their engagement portrait in Rockford, Illinois. With his older brother, William, George was one of Lemon Grove's earliest orchardists. Like others who sought California's gentle climate, the brothers suffered from respiratory ailments and had their lives cut short.

STAGECOACH STOP, 1894. George and Ida Troxell built this Victorian home in 1893. It doubled as a stagecoach stop and hotel for travelers, who stopped there to eat, wash up, and spend the night. The house faced cornfields and orchards. Today the site is still a destination—for patrons of the Home Depot, which replaced the house in 1993.

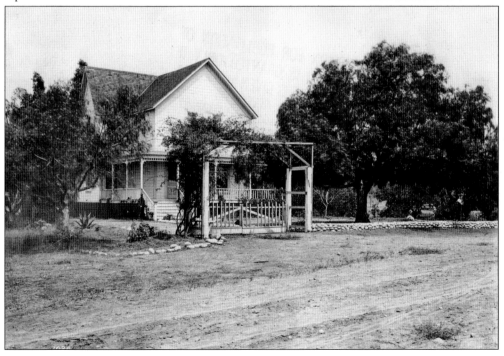

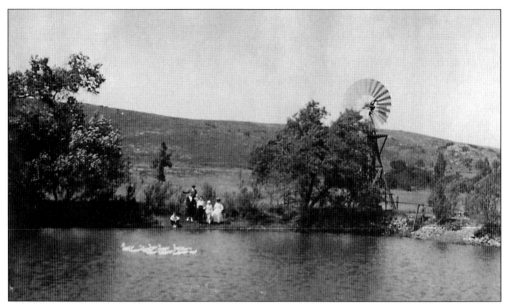

STAGECOACH STOP POND, C. 1913. Like all of the early homes in Lemon Grove, the Troxells' house had a pond and windmill behind it. The pond doubled as a reservoir, a critical element in a semiarid climate. The subsequent owner raised the ducks and geese seen here. Today North Avenue runs through the site from Olive Street to West Street.

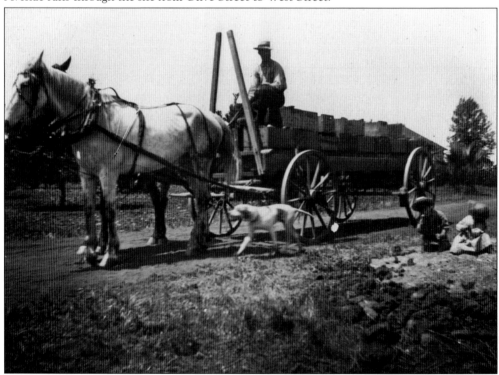

GEORGE GOOD, C. 1899. George Good hauls crates of fruit from his lemon ranch to the packinghouse. He and Nora Good and their children arrived in 1895 to start the ranch near present-day Lincoln Street.

SUNSET VIEW RANCH, 1895. Levi and Louella Geer purchased 30 acres from Joseph Allison for a citrus ranch and built this Eastlake Victorian. Its hilly location afforded sweeping views westward to San Diego, hence the name "Sunset View." The house still stands on Central Avenue. The tubercular Geer was a businessman in Danville, Michigan, when he married equally frail, 17-year-old Louella. For their health, they moved to Lemon Grove in 1894 with their daughter.

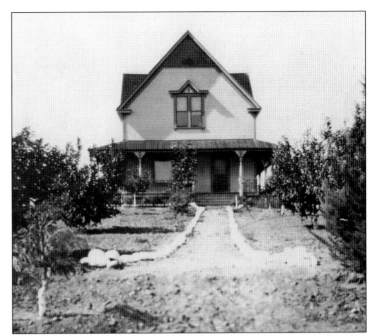

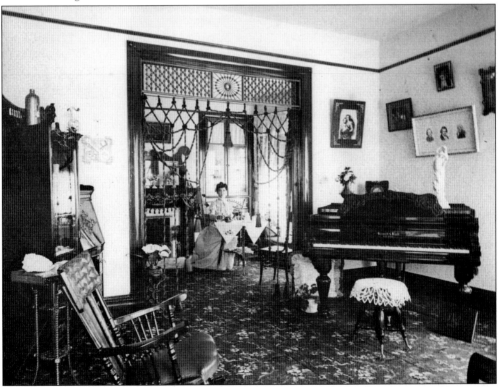

LOUELLA GEER AT HOME, 1897. Louella Geer sits at her tea table in the opulent setting of Sunset View Ranch. The Geers hired a young couple to run the lemon ranch, but when they bought their own ranch in National City, life turned grim for the Geers. Levi died in 1898, and Louella sold the ranch to Henry Hill in 1899. Ill and depressed, she died of a morphine overdose in 1901.

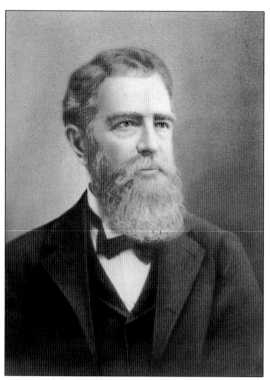

SEN. HENRY HILL, 1900. After California state senator Henry Hill and Agnes Hill purchased Sunset View Ranch in 1899, they invested in the flume in 1901, bought 20 more acres, and ran the ranch for a decade. As a Montana stockbroker and congressman, Hill had acquired a fortune in silver mining and banking. He became president of the California State Senate.

THE SUNBURY FAMILY, 1894. The Sunbury clan posed for a photograph in Massachusetts before setting out for California. Oscar (standing far left) and Pearl Sunbury bought a home in Lemon Grove and started a 20-acre citrus and poultry ranch. The family ran several businesses, bought more land, and built several homes. Ernest (baby in center of front row) ran the Lemon Grove Lumber Company from 1940 to 1955. Pearl Sunbury later became a columnist for the *San Diego Union*.

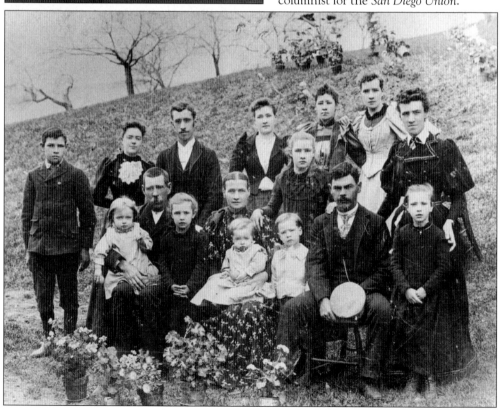

**WALTER AND EDITH (SILVIS) DENLINGER,
1915.** Childhood sweethearts Walter and
Edith Denlinger, of Hartland, Kansas, were
married in 1911 in the First Congregational
Church of Lemon Grove. They raised
two sons, Ernest and Albert, on a citrus,
poultry, and rabbit ranch that spanned
eastern Lemon Grove from Alton Drive
to Golden Avenue. She was a teacher, and
he was a bookkeeper for the Sonka Store
for 10 years, before launching their ranch
in 1923. In the 1950s, they sold portions
of the ranch but kept their Adams Street
home with its thriving fruit and banana
trees. (Courtesy Denlinger family.)

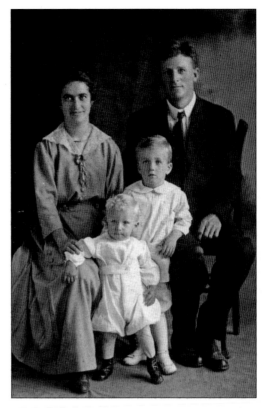

THE BEIDLEMAN FAMILY, 1918. Edgar and
Nellie Beidleman and their daughter, Adeline
(the youngest of eight children), stand outside
their Main Street home with its "Gold Star
Mother" sign and flag, which represented their
three sons fighting in World War I. Edgar, a
plumber and pipefitter, worked on the Allison
Flume in the 1890s and installed water lines
to local ranches. They helped to establish the
First Congregational Church of Lemon Grove
in 1894. A gifted landscape painter, Edgar was
part of the plein air group in Lemon Grove.

THE WAITE FAMILY, 1917. Jerry and Anna Waite and their daughters, Josephine and Emmaline, came to Lemon Grove in 1894 from Colorado to start a large citrus and poultry ranch. Waite Drive (now part of La Mesa) was named for them. Both girls attended the early Lemon Grove Grammar School.

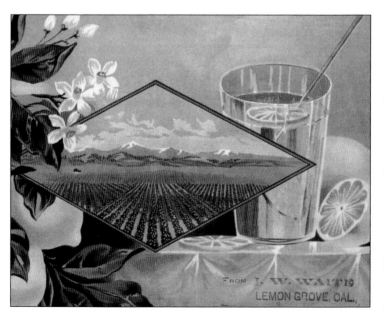

WAITE ORCHARD FRUIT LABEL, 1897. This is the evocative fruit label of the Waite orchard, showing Mount Miguel in the distance. Waite partnered with another pioneer orchardist, Arthur Lester, for whom Lester Street is named. Like other growers, they ran a showroom in the Midwest, where most railroads led before connecting to the Erie Canal and Eastern markets.

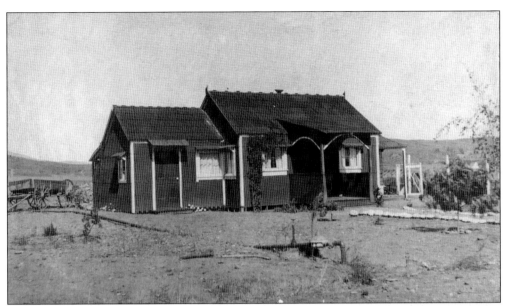

FLETCHER COTTAGE, 1911. Col. Edward Fletcher of Massachusetts came to San Diego in 1888 with $6.10 to pioneer in water, road, and real estate development. The three-time state senator built this Central Avenue cottage for his grandfather, Charles Fletcher. In the foreground are a new water meter and faucet connected to a pipe running toward the cottage. Thanks to Fletcher's efforts, piped water was in use in Lemon Grove homes by 1910.

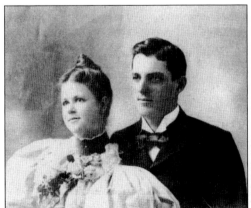

COL. EDWARD FLETCHER AND MARY (BATCHELDER) FLETCHER, 1896 AND 1950s. Col. Edward and Mary Fletcher are seen at left in their wedding portrait and at right in old age. The colonel died in 1955, leaving a matchless legacy of development in San Diego County.

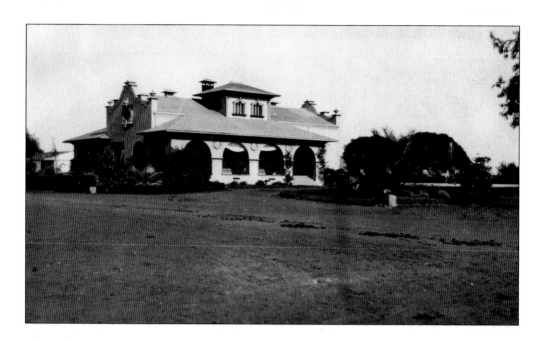

THE BRYAN HOUSE AND FOUNTAIN, 1896. Lemon rancher Col. Thomas. J. Bryan was a Civil War veteran and Montana cattleman. He commissioned architect Robert C. Reamer to design this 14-room, Spanish mission-style residence on the corner of Golden and Imperial Avenues (present site of Union Bank). Famous for its size, fountain, and gardens, the home was the scene of splendid parties attended by future president William Howard Taft and other notables. The house was moved in 1954 and later demolished.

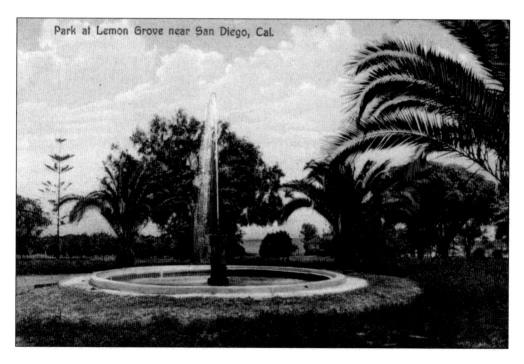

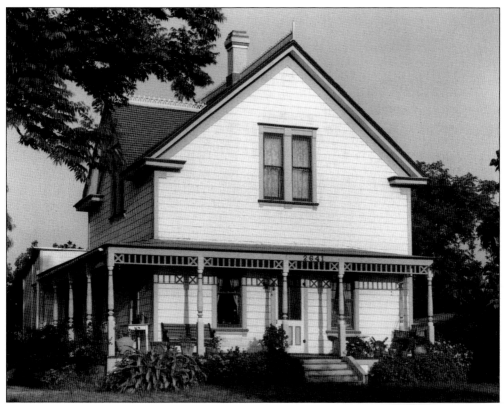

THE FELS RANCH, 1896. August and Augusta Fels of Minnesota established a lemon, olive, potato, berry, and hay ranch that grew from 10 to 500 acres, encompassing one-fourth of Lemon Grove. Berry Street was named for their strawberry fields. The Fels were related to the Philadelphia Fels Naptha Soap fortune. August's nine-room, redwood home built in 1896 still stands on Massachusetts Avenue. The women pitching hay in 1896 were hired locally. (Above, courtesy Pete Smith.)

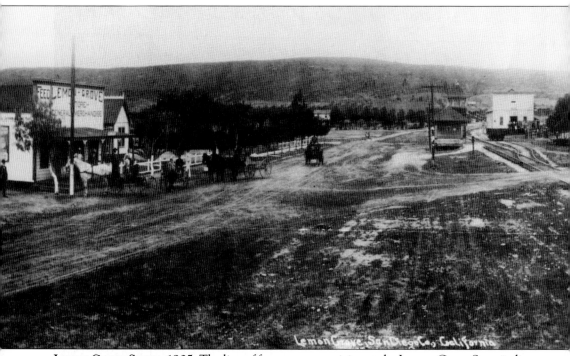

LEMON GROVE STORE, 1905. The line of farm wagons arriving at the Lemon Grove Store indicates its importance to pioneer ranchers from miles around. A large fruit packinghouse stands near the train depot. When the store burned down in 1906, J. C. Braiden built a temporary store on the site for feed merchant Milton Mason.

ANTON AND ANNA SONKA. The arrival of Anton and Anna Sonka marked a key moment in local history. Born in 1851 in Bohemia, Anton, like other young men, was prey to conscription by the warring armies of the Austro-Hungarian Empire. He fled with his brother, Joseph, to America to run cotton ginning and brick-making companies in Seguin, Texas. Anna Klein Sonka, born in 1859 in Shelbyville, Indiana, to German immigrant parents, joined family in Seguin about 1880 and married Anton about 1883.

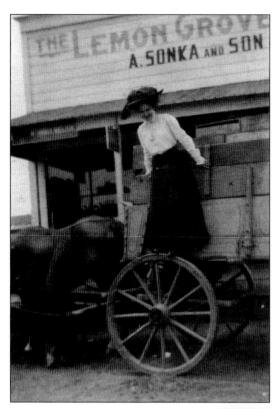

A. Sonka and Son, 1907. A family quarrel and Anton's frail health prompted the Sonkas' move to Santa Cruz in 1903 and to San Diego in 1906. In 1907, they fell in love with Lemon Grove and bought the store at Main and Pacific Streets, naming it for Anton and his eldest son. Anton died in 1909 and Anna in 1934. Here an unknown young woman posed on the wheel of a farm wagon outside the store. Fortunately, the two-horse team remained stationary.

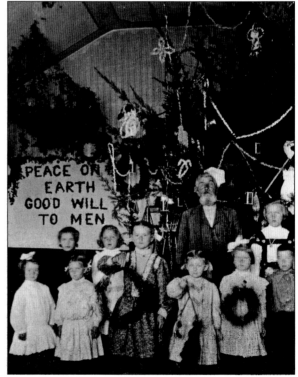

Christmas, 1907. Inside the town's first church, a local rancher, William O'Marr, leads local children in a Christmas program. They grew up to become founding members of the Lemon Grove Historical Society.

Three

AGRICULTURAL HEYDAY

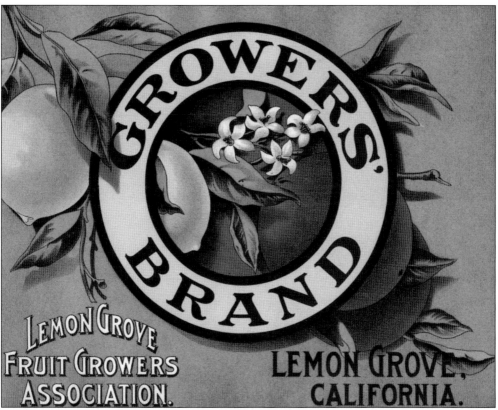

GROWERS' BRAND FRUIT LABEL, 1894. The Lemon Grove Fruit Growers Association was formed in 1893, so that ranchers could pool the expense of harvesting and shipping produce. Their signature Growers' Brand fruit label, designed in 1894, was glued to the ends of fruit crates. This and other "lug labels" remained in use for the next 40 years and came to signify the superior quality that won the association many awards.

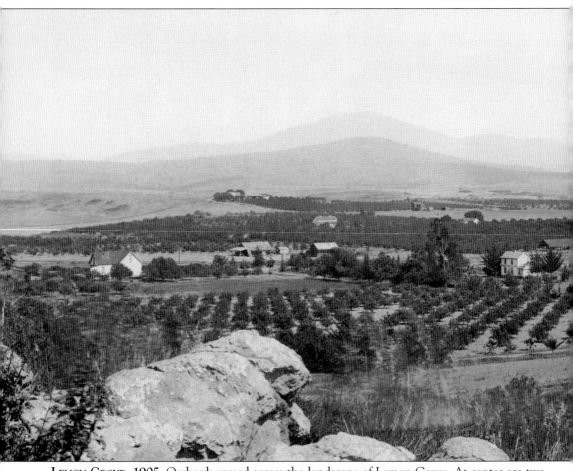

Lemon Grove, 1905. Orchards spread across the landscape of Lemon Grove. At center are two

On Honor Brand Fruit Label, 1894. With the On Honor Brand label, the Lemon Grove Fruit Growers Association proudly proclaimed that the top layer of flawless fruit signified that everything in the crate was perfect.

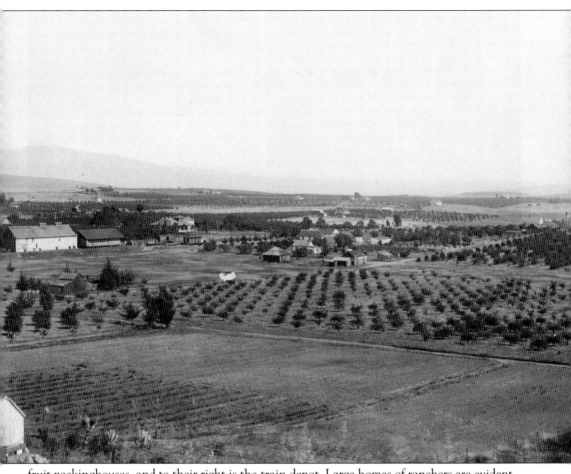

fruit packinghouses, and to their right is the train depot. Large homes of ranchers are evident.

TEMPTATION BRAND FRUIT LABEL, 1895. Fresh squeezed lemonade was taken to county fairs and agricultural associations to advertise Lemon Grove's crops and was served on many public and private occasions as this enticing Temptation Brand fruit label design indicates.

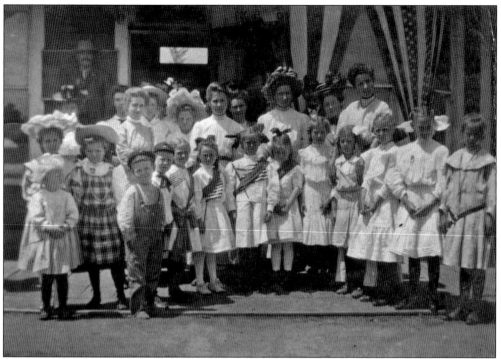

FOURTH OF JULY, 1906. Then, as now, the Fourth of July was cause for celebration. At the Lemon Grove train depot, children in their Sunday best prepare to sing the national anthem when the train pulls in with guests from San Diego, arriving for picnics, fireworks, and, of course, fresh lemonade.

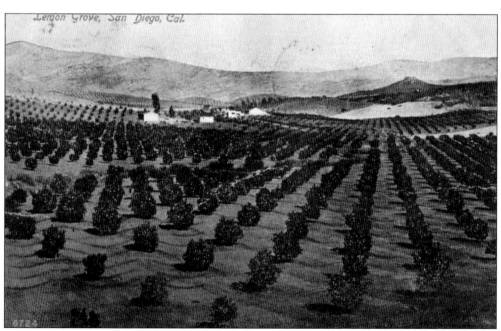

LEMON GROVE ORCHARDS, 1910. This was the view of Lemon Grove orchards looking toward Mount Miguel across the McTear Orchard near modern Lincoln Street.

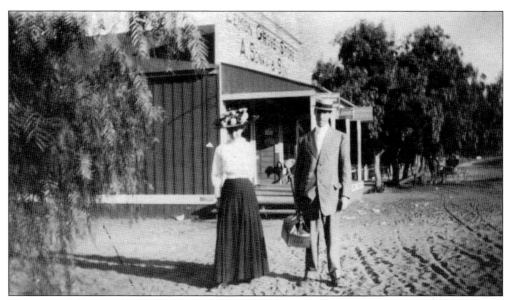

NEWLYWEDS ARRIVE, 1907. Charles and Alice Schults, just off the train, stand near the A. Sonka and Son store. They were part of the waves of first- and second- generation European immigrants, many of them German, who migrated to California early in the 20th century. Charles joined Tony Sonka in a variety of business ventures that helped to grow the town.

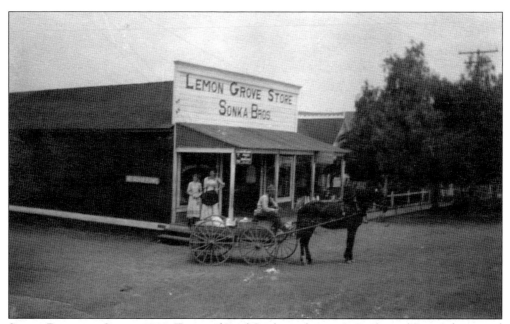

SONKA BROTHERS STORE, 1910. Tony and Emil Sonka took over A. Sonka and Son and renamed it the Sonka Brothers Store. Here Emil prepares to deliver an order to a local home. There were no house numbers in town until Henry Eckler, the local tax assessor's son, painted them on for 10¢ a number. People knew homes by color and location. In 1910, the local population numbered 500.

ARTHUR HAY, EARLY 1900s. In 1913, Arthur Hay and his wife, Grace, transformed an 1897 Lemon Grove bungalow into a Dutch Colonial Revival fronted by a graceful veranda. He was president of the Lemon Grove Fruit Growers Association from 1918 to 1923. An engineer, he helped to plan the 1915 exposition in Balboa Park. (Courtesy Carol Burke.)

GRACE HAY, EARLY 1900s. Grace Hay had been a violin soloist with the John Philip Sousa Band. The Hays later moved to San Diego's Mission Hills, where their historic home lives on. (Courtesy Carol Burke.)

PLUMOSA RANCH, 1913. The home of Arthur and Grace Hay was named Plumosa Ranch for the towering queen palms on the front lawn. Once the centerpiece of their 10-acre lemon and avocado ranch, the home thrives today. Their daughter, Jean Hay, is on the veranda. (Courtesy Carol Burke.)

THE LITTLE HOUSE, 1913. Dr. Clement Little and his wife, Joan, of Nebraska built this unusual Italian Renaissance–style home, which still stands on Central Avenue. He was a physician in both world wars.

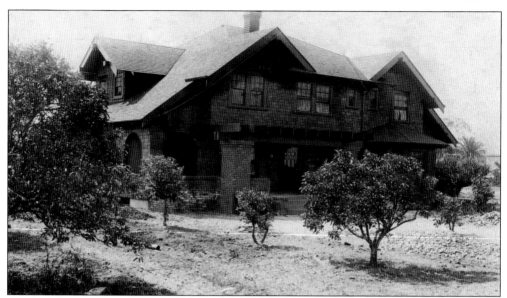

THE EVANS HOUSE, 1913. Oscar and Gertrude Evans built this shingled Victorian on Central Avenue on a small citrus ranch. They also ran a shoe store in San Diego. With only a "bucket brigade" available in Lemon Grove, the house later burned down.

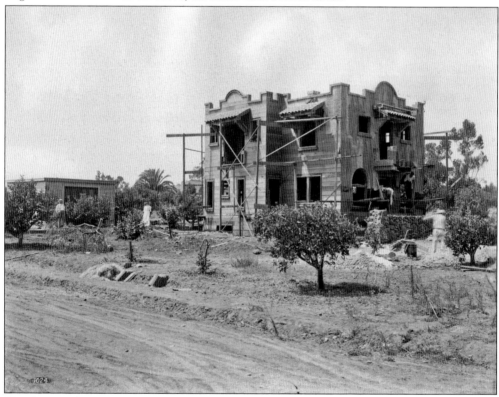

THE CORDITZ HOUSE, 1915. The Mission Revival home is seen under construction. Arthur Corditz, a businessman and asthma victim, did not live to enjoy his creation, which still stands on Central Avenue. California was the birthplace of the mission style so popular between 1905 and 1920.

40

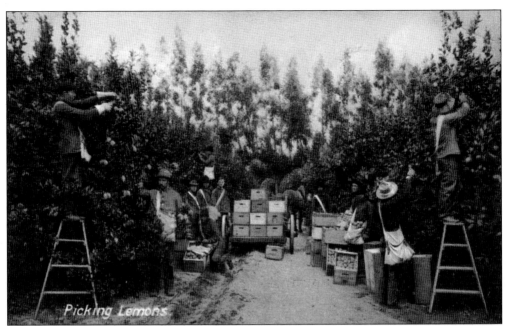

Picking Lemons

MEXICAN FRUIT PICKERS, 1910.
Lemon Grove's indispensable
Mexican migrant and Mexican
American labor force included
those who settled in Lemon
Grove and became vital
parts of community growth.
In 1918 alone, the growers'
15-inch-thick shipping record
indicated 5 million tons of fruit
shipped, a vivid demonstration
of the industry and drive of
the laborers and ranchers.

CASTELLANOS WEDDING, 1928.
The families of Tiburcio and
Refugio Castellanos settled
in Lemon Grove in the early
1920s and became leaders
in business and education.
Tiburcio worked at Benson
Paint in San Diego and was
greenskeeper at the La Mesa
Country Club Golf Course.
Present-day Fairway and Golf
Drives evolved from that period.
(Courtesy John Castellanos.)

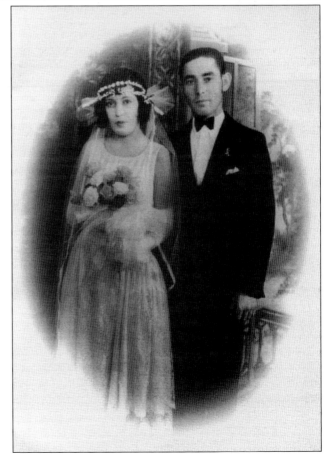

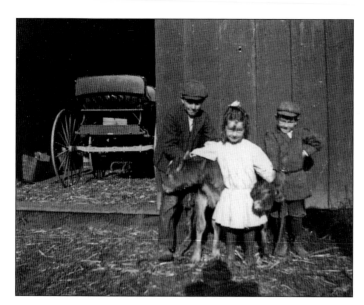

THE GOOD CHILDREN, 1912. Charles and Mary Good's children—Elwin, Mildred, and Hugh—tend two calves on the family citrus ranch on Buena Vista Avenue near Waite Drive. Local children grew up with a range of farm animals and pets well into the 20th century.

WILLIAM GOOD AND FAMILY, 1912. The Good family transports a check-shirted scarecrow to one of their fields near present-day Buena Vista Avenue. There were three Good families in town, all connected to the orchard and dairy industries, if not to each other.

THE FISHER FAMILY, 1915. In 1912, William and Alice Fisher of Massachusetts established Cuyamaca Estates, a citrus ranch between Roosevelt and Central Avenues. Fisher Lane is named for the family. Two pillars still stand on Buena Vista Avenue, marking the ranch. Daughters Fay (left) and Marian are astride "Oz."

LEMON GROVE LAND COMPANY, 1914. William Fisher ran the Lemon Grove Land Company. Window signs advertise fire and auto insurance and "7 ½ acres fruit bearing trees $1600." Fronted by new electrical poles, the company stood south of the Sonka store on as yet unpaved Main Street.

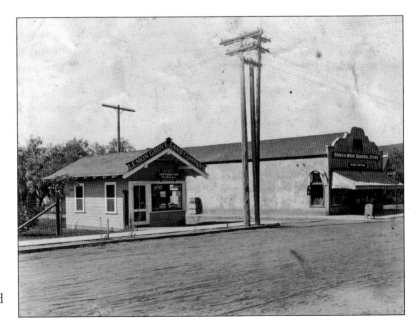

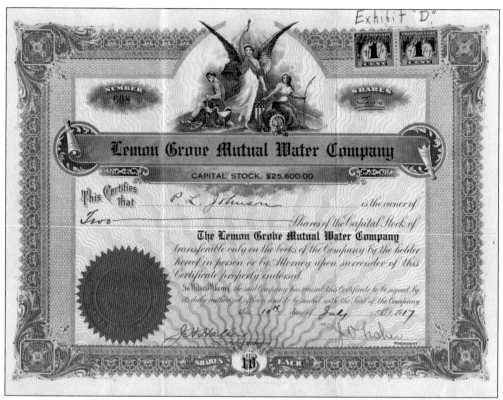

LEMON GROVE WATER CERTIFICATE, 1917. Pher Johnson, a Swedish immigrant who bought the Troxell stagecoach stop in 1912, invested in two shares of stock in the Lemon Grove Mutual Water Company, where William Fisher was president. Every local grower had a stake in the company.

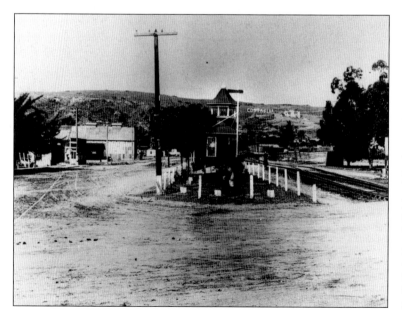

TRAIN DEPOT AND COSTA BELLA, 1915. Golden Avenue sweeps across the train tracks in the foreground. The depot is surrounded by bollards to protect it from auto and horse traffic. W. F. Hunt's 50-acre Costa Bella subdivision and his palatial residence stand north of town.

MAIN STREET, 1914. The growing community now featured a two-story schoolhouse, parsonage, handsome new church, and another new home on Main Street. The steeple of the 1897 church, now moved west to Olive Street, peeks up at rear.

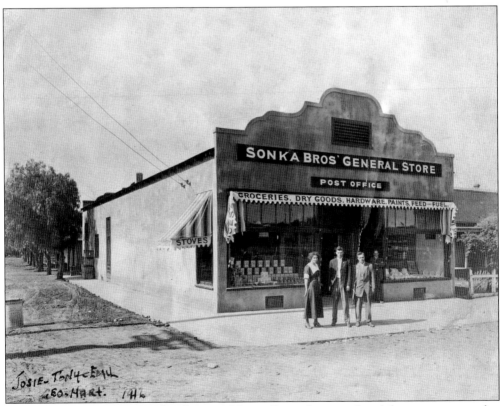

SONKA STORE, 1916. In 1912, this charming Mission Revival store replaced the temporary wooden store at the corner of Main and Pacific Streets. From left to right, siblings Josephine, Tony, and Emil Sonka stand on the sidewalk. George Hart, their bookkeeper who lived a block away, is in the doorway. The Mission Revival store lives on as the home of today's Grove Pastry Shop.

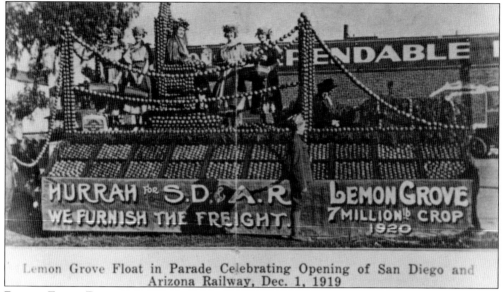

Lemon Grove Float in Parade Celebrating Opening of San Diego and
Arizona Railway, Dec. 1, 1919

PARADE FLOAT, DECEMBER 1, 1919. Lemon Grove's citrus-draped float carried a boy scout, local beauties, and a triumphant message—a 7 million pound crop for 1919–1920. The San Diego parade celebrated John D. Spreckels Day and the opening of the San Diego and Arizona Railway.

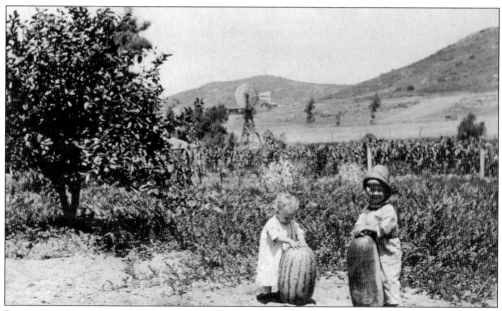

PEARL AND RUBY JOHNSON, 1919. Pearl (left) and Ruby Johnson, the toddler daughters of Pher and Anna Johnson, are seen with the citrus trees and giant watermelon on the family ranch. North Avenue now runs through the cornfield at rear.

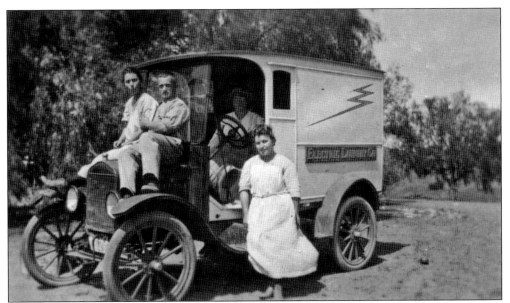

ELECTRIC LAUNDRY COMPANY, C. 1918. Established during World War I in downtown San Diego, the Electric Laundry Company picked up and delivered laundry countywide and was a boon to busy ranching households. The company's building has been designated a City of San Diego historic resource and is slated for adaptive reuse as the Laundry Lofts project. Here the Model T truck delivered to the Waite Orchard, where Emmaline (standing) and Josephine Waite (seated on hood) posed for posterity.

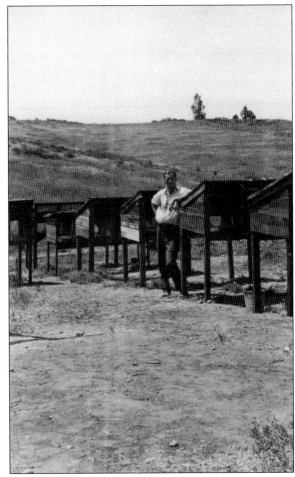

ECKLER'S RABBITRY, 1930. Sanford and Lena Eckler came to Lemon Grove from Ohio in 1927 to run a 20-acre citrus, poultry, and rabbit ranch and Eckler Electric. She was the town librarian. They lost their $30,000 nest egg and much of their land to the infamous Mattoon Act in the 1930s. In its heyday, the rabbitry raised and sold thousands of tender rabbits.

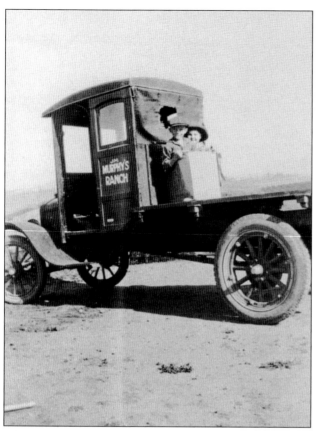

J. H. Murphy's Poultry Ranch, c. 1918. The Scottish John Hugh and Ada Murphy established a large poultry ranch near San Miguel Avenue. Chickens were slaughtered on site and sold fresh to local residents and those in nearby towns. John and Harriett Murphy sit on their father's Model T truck. The Murphys lived in San Diego and were extensive landholders.

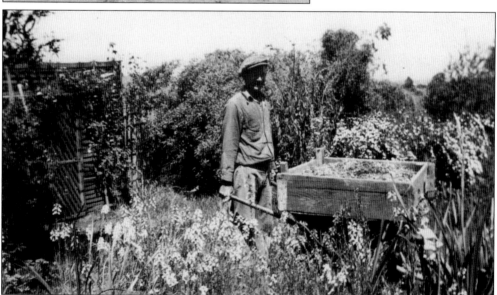

Chicken Manure, 1930. This free, abundant product of local poultry ranches was a mainstay of Lemon Grove gardens well into the 20th century. Here Earl Jenner hauls a wheelbarrow load of manure from Murphy's Poultry Ranch around the corner to his Vista Street garden, where his fruit and cut flower crop was booming. (Courtesy Mary Stumborg Martin.)

PROMOTIONAL BROCHURE, 1919. The brochure heralded Lemon Grove as "San Diego's nicest suburb" where "life is one continuous round of pleasure." The town now had 800 residents and 200 homes. "See Naples and die; see Lemon Grove and live," urged the purple prose.

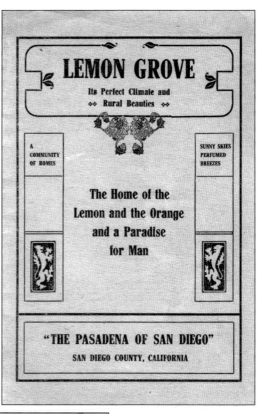

ED FLETCHER COMPANY ADVERTISEMENT, 1918. Edward Fletcher bought and sold hundreds of acres in Lemon Grove. The intrepid pioneer first lived in a sod house on Vista Street and saved $5 per week while building his real estate empire.

49

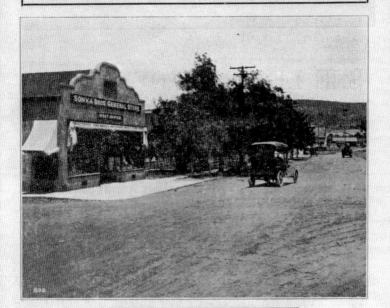

Sonka Bros. General Store

SONKA BROS., PROPRIETORS

Complete Line General Merchandise

| Home Phone 333 | GROCERIES | Sunst La Mesa 29W |

DRY GOODS SHOES HARDWARE PAINTS
HAY GRAIN FEED FUEL AND SULPHUR

AUTO TIRES

FULL LINE OF AUTO ACCESSORIES GAS AND OIL

LEMON GROVE, CAL.

SONKA STORE ADVERTISEMENT, 1919. This full-page advertisement shows why the Sonka store continued to be the region's shopping mecca. With the blacksmith forge gone and auto tires ascendant, the variety of goods for sale proliferated, along with the population. Yet livestock of all kinds continued to outnumber humans, and the Sonkas continued their brisk trade in feed and hay.

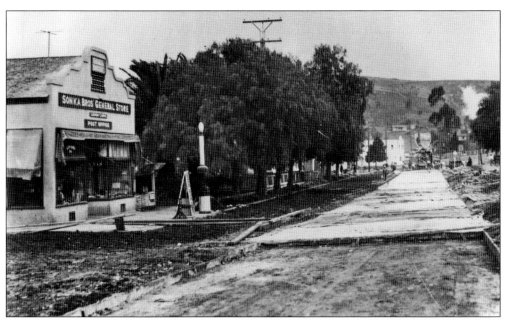

PAVING MAIN STREET, 1928. With 1,200 residents and their wagons and cars hurling dust everywhere, streets needed asphalt. Here with a gas pump now standing outside Sonka Brothers' General Store, Main Street is paved, or macadamized, for the first time.

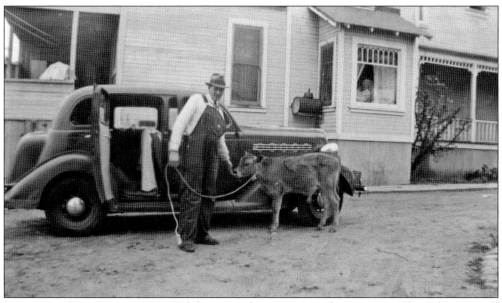

LOADING A CALF, LATE 1930S. With horses and wagons a receding memory, Pher Johnson's calf rode in style to be slaughtered in Lakeside.

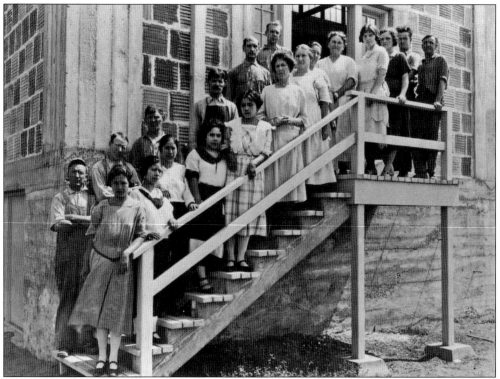

COMPANY TOWN, 1927. Anglo and Mexican American workers posed on the steps of the Lemon Grove Fruit Growers Association packinghouse. From teachers to laborers, everyone worked there in the Great Depression.

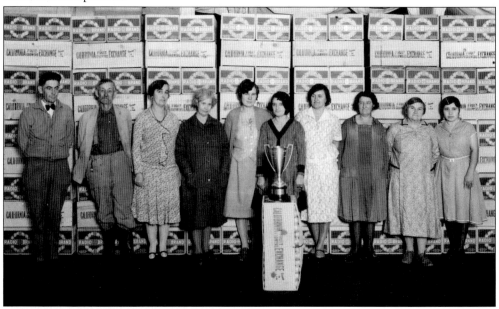

THE WINNERS, 1928. Don Hutchings (far left), manager of the Lemon Grove Fruit Growers Association, posed with nine packers the year they won another trophy in the California Fruit Growers Exchange competition. The Radio Brand fruit label marked a transition from the 1894 Growers Brand label.

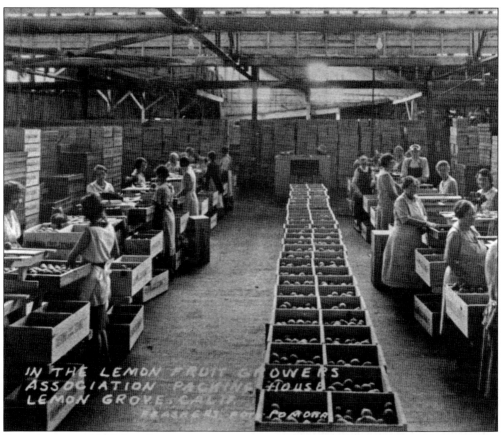

PACKINGHOUSE, 1930. Local women worked in the packinghouse during the Depression, earning $3 a day for packing 10,000 lemons. Minimum wage was 33.3¢ an hour. Lemon packing was preferable to picking vegetables at $1.50 a day. Between May and September, over 200 freight cars of lemons left Lemon Grove (two to three cars each day), though washing and packing lemons continued year-round as different species ripened.

TOM MOORE, 1933. The Moores weathered the Depression on a large fruit and vegetable ranch established on El Prado Avenue in 1912. Daughters Mary (left) and Arleen were the "village peddlers," selling fresh produce from a wagon pulled through neighborhoods during the 1930s.

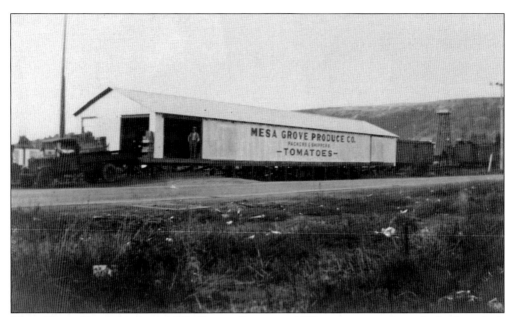

MESA GROVE PACKINGHOUSE, 1932. Renner Prevost, a 1912 pioneer, stands on the loading dock of his Mesa Grove packinghouse near the center of town. He had 15 acres of tomatoes.

BELL PEPPERS LABEL, 1932. To survive the Great Depression and periodic freezes, Prevost and other growers planted a variety of crops between the fruit trees to stay in business. There were now 1,500 residents in town and as many horses. During the Depression, gas averaged 6¢ a gallon, but local people relied more on horsepower to save money—and they were growing their own hay and feed anyway.

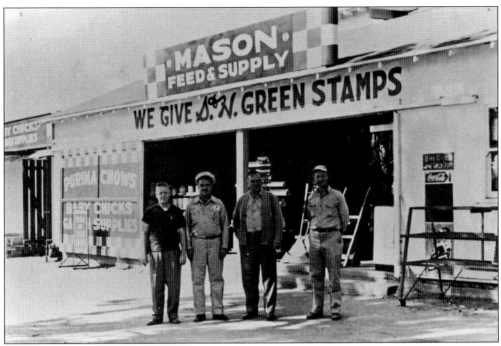

Mason Feed and Supply, 1937. Launched in 1891, Mason Feed and Supply—guided by the founder's son, Channing Mason (far left)—continued to employ local people during the Depression. The company had the first Coca-Cola vending machine in town.

"The Big Lemon", 1935. In good times and bad, the lemon stood sentinel by the railroad tracks, proclaiming the town's prime product.

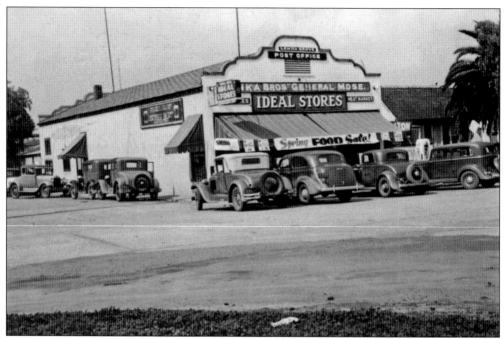

SONKA BROTHERS' GENERAL STORE, MARCH 8, 1937. Now flanked by flivvers instead of horses, the Sonka Brothers' General Store had merged with the Ideal Stores chain. Tony Sonka extended generous credit to Depression-era families and ranchers, who paid grocery bills when their crops sold or traded homemade bread and preserves for other products.

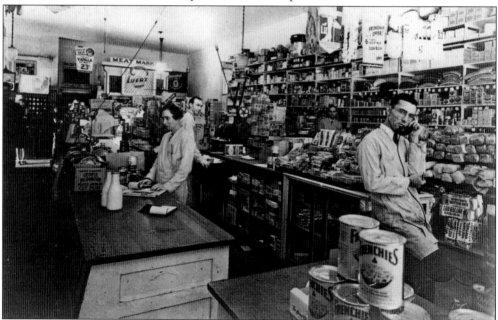

SONKA STORE INTERIOR, 1939. Crammed with wares, the interior of the store is pictured here. The store's owners hired locally. Counter clerk Genevieve Bond Whiting was a town native and daughter of the owner of the original 1891 store. George Johnson (on the phone), Rolla Hamilton (center), and butcher Anton Brunner (rear) all lived in town.

HOWARD HUNTER, 1945. Howard and Alice Hunter arrived in 1918 to care for relatives stricken in the influenza pandemic. They bought land from local builder George Simpson and started Hunter's Nursery in 1919. Famed for its roses and citrus trees, the nursery thrives today under family ownership on Sweetwater Road as the oldest, continuously operated business in town. (Courtesy Betty Hunter.)

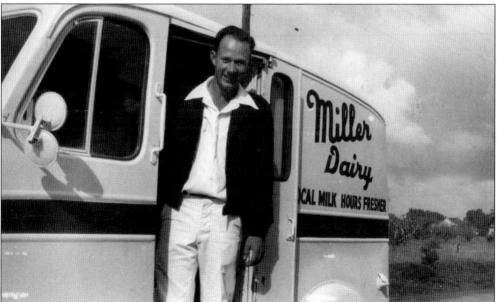

MILLER DAIRY, 1948. The 16-acre Miller Dairy, started by Charles Miller in 1926 "with one cow and a lemon orchard," milked its last cow in February 1985, when the Millers sold the land for the Miller's Ranch subdivision and 300 cows went to Chino. Generations of residents shopped at the dairy and delighted in the sight, sound, and smell of cows at midtown. Seen on his Detroit Industrial Vehicle Company (DIVCO) milk truck, Bill Miller drove his route in more trusting times, entering unlocked kitchen doors and depositing milk bottles directly into the refrigerator. (Courtesy Brumbaugh-Smith Archive.)

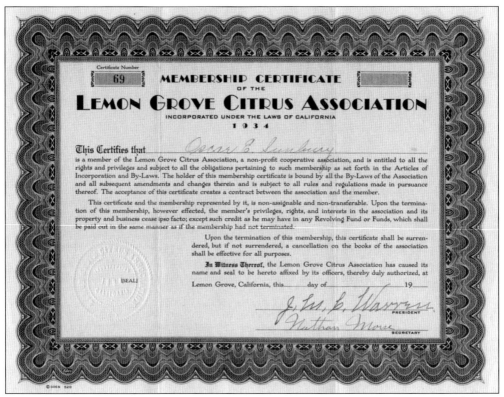

LEMON GROVE CITRUS ASSOCIATION, 1934. Lemon Grove Citrus Association became the new name for the original Lemon Grove Fruit Growers Association. As croplands diminished and cash flow tightened during the Depression, the surviving ranchers began to focus solely on lemons and oranges.

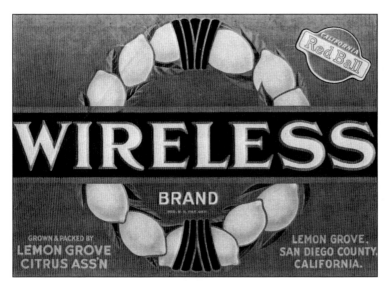

WIRELESS BRAND, 1934. Wireless Brand was a technology-minded fruit label that marked the transition from the 1893 Lemon Grove Fruit Growers Association to the Lemon Grove Citrus Association as well as the merger with the larger California Red Ball fruit and vegetable shipping operation.

Four

THE THREE RS AND HOW THEY GREW

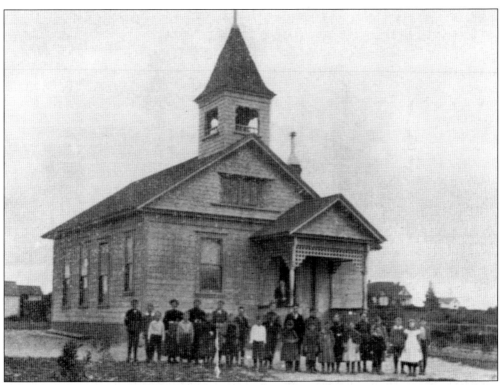

FIRST SCHOOLHOUSE, 1894. The school district was formed in 1893 and was housed temporarily in William Hurst's barn on Central Avenue until this one-room grammar school was built at Olive and Church Streets. The iron school bell arrived by train in 1894, probably from Sears Roebuck. The school later became a private home and was demolished in the 1990s.

SCHOOLCHILDREN PLAYING, 1906. The children and their teacher, Ada Samples, play behind the first schoolhouse.

UPPER FOUR GRADES, 1907. Grades five to eight posed outside the first schoolhouse. They were children of Anglo pioneer families like Lindsay, Silvis, Sunbury, Good, White, and Sonka.

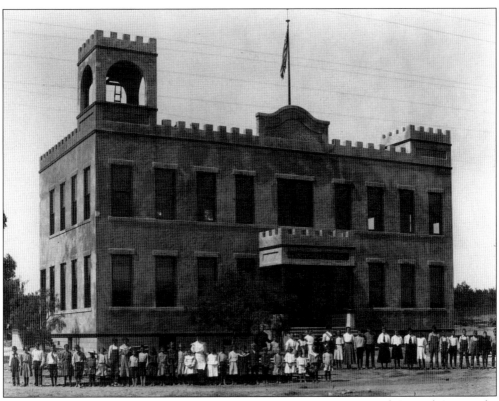

SECOND SCHOOLHOUSE, 1908. The "Castle" was built at Main Street and Central Avenue for grades one to eight. The imposing, two-story, four-room school reflected local pride in the growing town. The school bell was moved to this school, which was torn down in 1924.

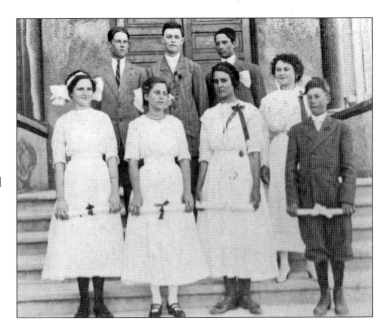

GRADUATION, 1910. The first graduating class of the "Castle" typified rural America as many youngsters finished school in the eighth grade and moved directly into farm work. Until the 1920s, a high school diploma was considered an achievement and implied a professional or business future. Some of these students took the train to San Diego High School and later worked in nursing, law, business, and agriculture.

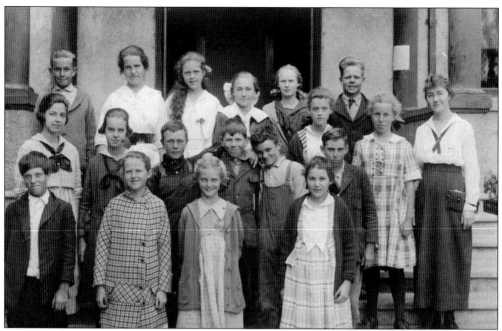

UPPER THREE GRADES, 1919. Grades six, seven, and eight posed outside the "Castle." Camp Fire Girls wear neckerchiefs. Homemade and hand-me-down clothes are evident.

THIRD SCHOOLHOUSE, 1924. This larger, Romanesque-arched school was built on Lincoln Street for grades one to eight. There were 167 Anglo, Asian, and Mexican American pupils. The school bell was moved here in 1924. In 1931, the school was the scene of the first successful, court-ordered, desegregation case in the nation, predating by 23 years the more famous *Brown v. Board of Education* in Topeka, Kansas.

LECCION XXX.

Diego	brinca	tengo miedo
jugar	balsa	vamos
lago	Mira	seguro-a
Ay		

Vamos en el lago, Juana. Mira, tengo una balsa.

Ay, Diego! tengo miedo de jugar en el lago.

Mi balsa es segura. Un hombre la hizo.

¡Brinca! ¡Brinca!

No puedo brincar. Tengo miedo.

LESSON XXX.

Jāmes	jŭmp	I am ăfrāid
to plāy	răft	let ŭs go
lāke	See	sāfe
O		

Let ŭs go on the lāke, Jāne. See, I have a răft.

O, Jāmes! I am ăfrāid to plāy on the lāke.

Mȳ răft is sāfe. A măn māde it.

Jŭmp on! Jŭmp on!

I can not jŭmp. I am ăfrāid.

Libro Primario, **1918.** Published in 1885, this Spanish-English reader was used in the Lemon Grove School District from about 1910. Students were taught both languages, an early recognition of the region's heritage and a pioneering effort in bilingual education. Written on the flyleaf in pencil is "Josephine Waite August 16—1918." She was the daughter of Anglo pioneer ranchers, Jerry and Anna Waite. Three months later, she died from influenza.

JEROME GREEN, LATE 1920S. Jerome Green, the principal of the Lemon Grove Grammar School, was a Notre Dame University graduate who aided Guglielmo Marconi with his transatlantic radiotelegraph achievements. Acting under school board orders on January 5, 1931, Green sent 75 Mexican American pupils to a hastily built, segregated, "Americanization" school two blocks away.

GRADES THREE AND FOUR, 1928. Robert Alvarez Castellanos (third row, left) became the plaintiff in the *Robert Alvarez v. the Lemon Grove Board* segregation case. Born in La Mesa and a bright student, he grew up to found the huge Coast Citrus Company. The plaintiffs won on March 11, 1931, after a school boycott and lawsuit waged by Mexican American parents.

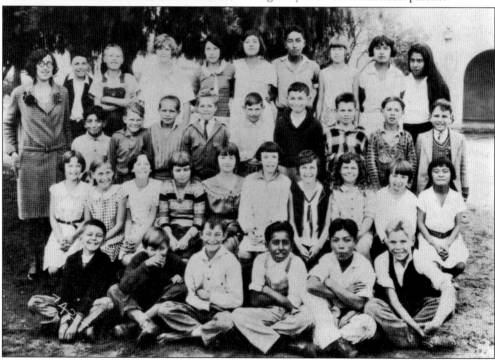

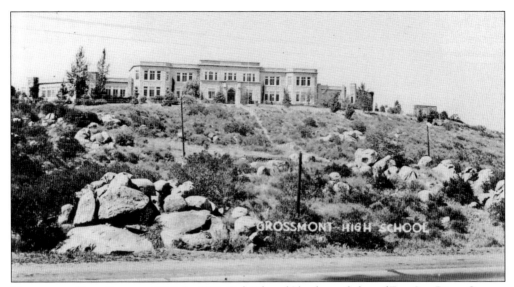

GROSSMONT HIGH SCHOOL, 1922. In 1920, Col. Edward Fletcher, a father of East San Diego County development, donated 14 acres for the first high school in East County. Before then, students had taken the train to San Diego High. Built of granite from Fletcher's own quarry, Grossmont High School was completed in 1922 and nicknamed the "castle on the hill." Today it houses the administration for the Grossmont Union High School District, encompassing a dozen high schools.

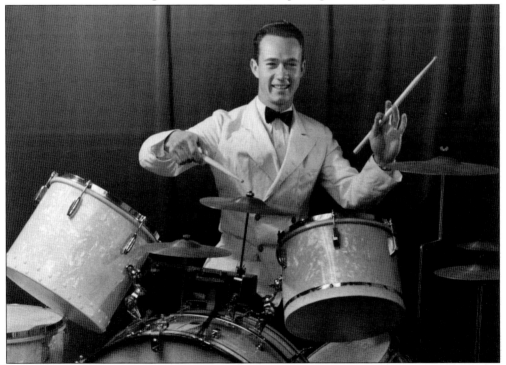

BILL MILLER, GROSSMONT JAZZ BAND, 1940. Bill Miller, the 19-year-old heir to Miller Dairy, played drums at Grossmont High School, continued to play with the Italian Paisanos, and plays today at the Chula Vista Senior Center. With his brother, Pete, Bill ran the dairy until it closed in 1985. (Courtesy Bill Miller.)

HARMONICA BAND, 1938. The district's music program started in 1933 in the Lemon Grove Grammar School with harmonica bands, directed by Mrs. Sorneson, which performed on the radio and at civic meetings.

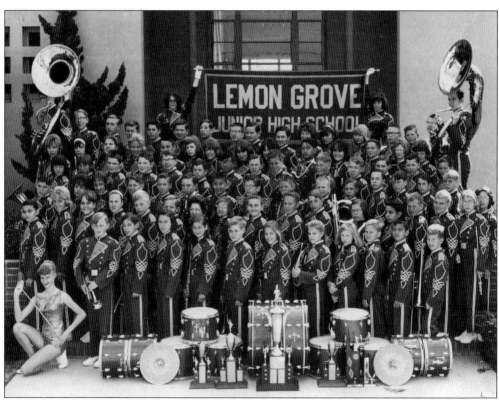

MARCHING BAND, EARLY 1960s. Sporting spiffy new uniforms and instruments, the Lemon Grove Junior High School ensemble began a 40-year streak of music awards.

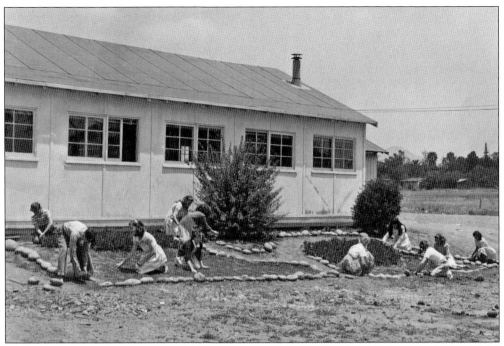

VICTORY GARDEN, 1942. Planting "Victory Gardens" outside the cafeteria became part of the grammar school curriculum during World War II.

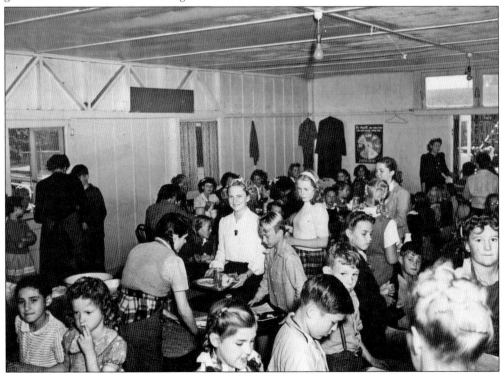

CAFETERIA, 1943. The 1931 Americanization school was moved to the grammar school for use as a cafeteria, then for storage, and later demolished.

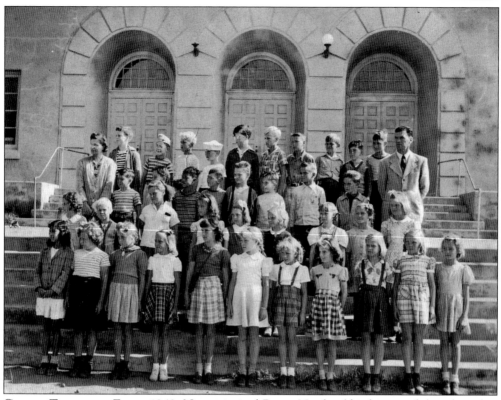

GRADES THREE AND FOUR, 1943. New principal Byron Netzley (third row, right) and teacher Marie Adams (third row, left) posed outside the grammar school. Pupils included grandchildren of pioneer families. Netzley scrounged for food and gas ration stamps for the school during World War II and often drove the school bus himself.

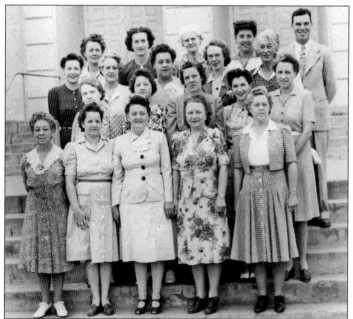

FACULTY, 1945. Byron Netzley is shown with his faculty. In the back row, second from right, is veteran teacher Katherine Elliott, who taught English to Mexican American pupils for 30 years and played the organ at the First Congregational Church.

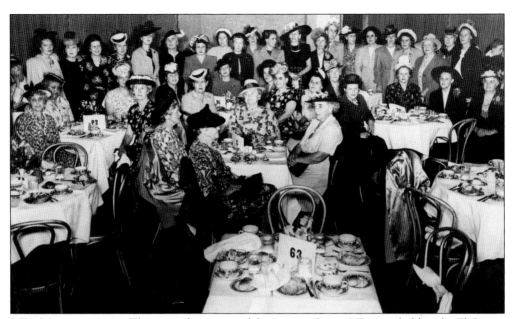

PTA Meeting, 1948. The annual meeting of the Lemon Grove PTA was held at the El Cortez Hotel, San Diego. Forty past and present members honored veteran teachers and discussed the impending construction of eight new schools for some 1,600 pupils.

Groundbreaking, 1948. From left to right architect Sam Hamill, Supt. Byron Netzley, PTA president Mrs. Alexander, and an unidentified man symbolically break ground for the district's second school, Golden Avenue School.

LEMON GROVE JUNIOR HIGH, 1953. Lemon Grove Junior High retained the Romanesque arches of the old grammar school until 1976. These seventh and eighth graders were in the first wave of the expanded school district, then educating nearly 3,000 pupils.

PALM JUNIOR HIGH SCHOOL, 1958. Palm Junior High School, the second junior high school, was needed to accommodate baby boomers. Like Mount Vernon School, it was built on orchard lands formerly owned by British immigrants William and Ada West.

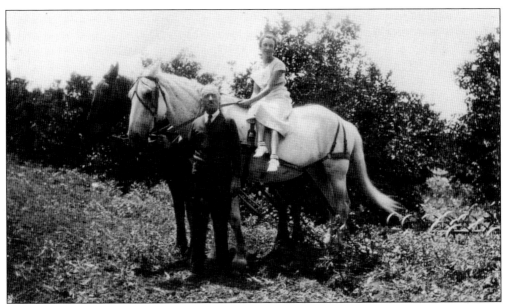

WILLIAM WEST, 1930s. William West leads a visitor, Maggie Barton, on horseback through his orchard. He arrived in 1914 to run a 20-acre lemon and 1,000-hen ranch. He budded and planted his own trees, was president of the citrus association from 1922 to 1957, and helped to develop the Helix Irrigation District. He bought the town's first (used) fire engine from Tijuana. He died in 1976, at the age of 101, in his home on Mount Vernon Street.

BUILDING SAN ALTOS SCHOOL, 1958. Located on the town's southerly border, San Altos School was one of six elementary schools in an expanded district that included children from southeast San Diego.

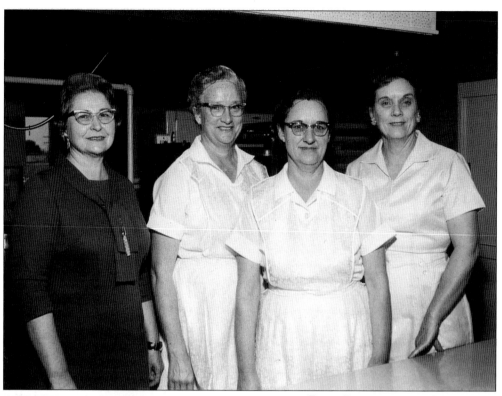

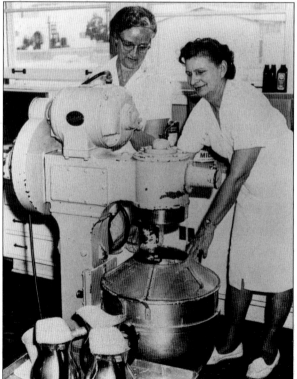

RUTH PFISTER, 1970s. District Food Services director Ruth Pfister (left) wrote the public school nutrition guidelines for the California State Education Department. She ran the cafeteria "like a general," said Alta Holmberg (second from left), flanked by Dolores Hequitt and Verna Williams. Hairnets, stockings, spotless uniforms, and surgically clean hands were de rigueur. Pfister traveled to the Port of San Pedro to purchase navy surplus kitchen equipment for the cafeteria.

CAFETERIA BREAD MAKING, 1970s. Alta Holmberg (left) supervises operation of a navy surplus bread maker in the school district kitchen, where all school lunches were made from scratch according to Ruth Pfister's nutritionally balanced recipes.

GLORIA CASTELLANOS CAMPBELL, 1939–2002. History came full circle when Gloria Castellanos Campbell joined the district faculty and taught for 38 years; her parents were among the segregated pupils in the 1931 case. One of the most beloved teachers in the district, Campbell's untimely death from cancer inspired a permanent memorial in the garden of Lemon Grove Middle School. (Courtesy John Castellanos.)

JOHN CASTELLANOS, 1974. John Castellanos (seen at left in 2003), the nephew of Gloria Castellanos Campbell, has taught bilingual education at Mount Vernon School for 28 years. Principal Gina Potter is at right. The school opened in 1960 and was the last of the eight schools to be built. (Courtesy Mount Vernon School.)

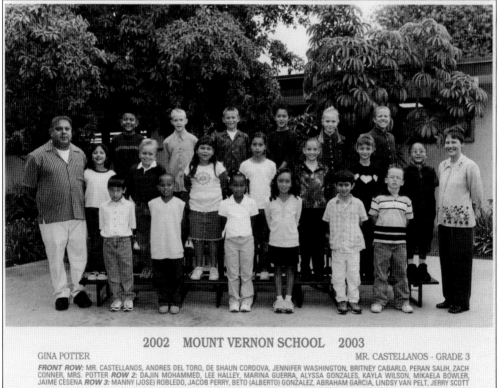

2002 MOUNT VERNON SCHOOL 2003

GINA POTTER MR. CASTELLANOS - GRADE 3

FRONT ROW: MR. CASTELLANOS, ANDRES DEL TORO, DE SHAUN CORDOVA, JENNIFER WASHINGTON, BRITNEY CABARLO, PERAN SALIH, ZACH CONNER, MRS. POTTER *ROW 2:* DAJIN MOHAMMED, LEE HALLEY, MARINA GUERRA, ALYSSA GONZALES, KAYLA WILSON, MIKAELA BOWLER, JAIME CESENA *ROW 3:* MANNY (JOSE) ROBLEDO, JACOB PERRY, BETO (ALBERTO) GONZALEZ, ABRAHAM GARCIA, LINDSY VAN PELT, JERRY SCOTT

THE WALL STREET JOURNAL.

© 1999 Dow Jones & Company, Inc. All Rights Reserved.

VOL. CXLI NO.96 Monday, November 25, 1999 Internet Address: http://wsj.com

CLASS ACT

As education software moves off the PC, it's opening up a new world for teachers and students

LAST MONTH, WHEN Barbara Allen asked her sixth-grade class at Lemon Grove Middle School to compile a scrapbook on the Sputnik space launch 42 years ago, Ms. Allen was, in a sense, creating her own little bit of history.

Ms. Allen, who directs LemonLINK, the Lemon Grove, Calif., school district's Internet-based computer network, sent out her assignment via e-mail. Her students scoured Web sites for material abut Sputnik, composed their essays on stripped-down computers specially designed to run on Internet-based servers, and submitted them electronically, complete with slides of the Soviet space shot culled off the Net.

Before the LemonLINK system, the school's PCs operated off desktop software. The computers were old and it would have been costly to keep upgrading and maintaining the system. What's more, most of the computers didn't have the power to run new applications like Windows 95 on their hard drives. So the school decided to turn to the Net.

After years of relying on PC-based technology, cash-strapped school districts like Lemon Grove are at last getting their chance to cash in on Internet economics. Instead of spending money on expensive upgrades, schools can use their old PCs or basic computers called thin client devices to run new and fast programs off a Web-based server at an application service provider, or ASP. For some schools, these Web-based systems are dramatically changing the cost of teaching and the way their pupils learn.

"School systems will be one of the biggest beneficiaries of the shift onto the Web," says Edward Iacobucci, founder and chairman of Citrix Systems Inc. The Fort Lauderdale, Fla., company provides technology that allows schools with older PC's or terminals to run Unix, Windows or Java-based software applications over the Internet from an ASP'S Web-based server."

"We can replace all the hardware with an appliance that's as easy to run as a telephone," says Mr. Iacobucci. "There's no complexity at the user end. People are just starting to grasp the ramifications of this."

The Lemon Grove school district used Citrix's software to convert its computer system. Before it did, school-district officials faced a dilemma: They had to decide whether to put money into upgrading their district's aging desktop computers of pay for more immediate needs, like repairing school buses. The old PC-based network ate up a lot of money in maintenance costs and upgrades. By using the Internet-based program, they are saving

WALL STREET JOURNAL, 1999. The Lemon Grove School District's Internet-based computer network, LemonLINK, made headlines and catapulted the district into the 21st century. Before LemonLINK, the schools' aging computers operated from desktop software. Now the same PCs run new, fast programs off a Web-based server. Students can submit work electronically, replete with slides, artwork, and graphs. (Courtesy *Wall Street Journal*.)

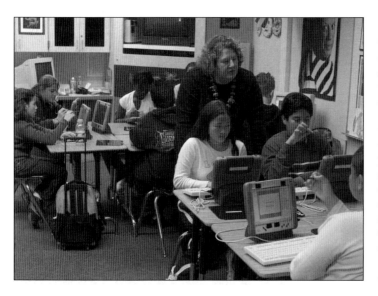

STUDENTS IN CYBERSPACE, 2002. Samantha Swann, science teacher, works with middle school students on Web tablets (a precursor to the current E-Pads) to create PowerPoint presentations. The students can receive and execute assignments by e-mail by using Windows software applications. Cost savings to the school district are huge. (Courtesy Lemon Grove School District.)

Five

SPORTS, LEISURE, FAITH, AND CULTURE

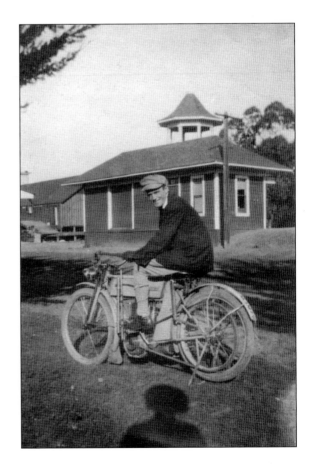

SCHNITZLEIN'S MOTORCYCLE, 1912.
Ted Schnitzlein's sister, Mabel,
photographed him on his Indian
motorcycle, the first in town. Their
parents, Fred and Teresa Schnitzlein,
battling asthma, had sold their
Connecticut produce business
and decamped for Lemon Grove,
where they bought Sunset View
Ranch. The motorcycle and Ted's
attire (boots, leggings, gloves, and
cap) were the envy of the town.

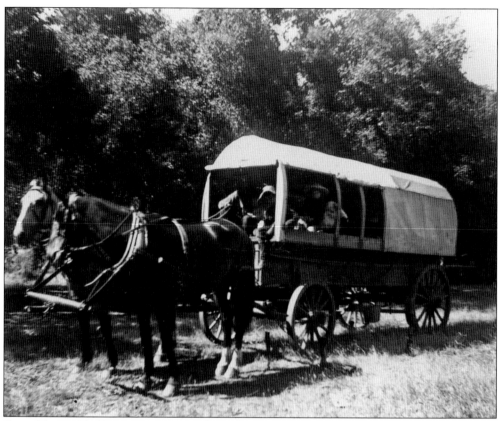

Good Family En Route, 1900. Local families were ardent campers, often to the Cuyamaca Mountains. They rigged canvas over farm wagons and packed tents and equipment.

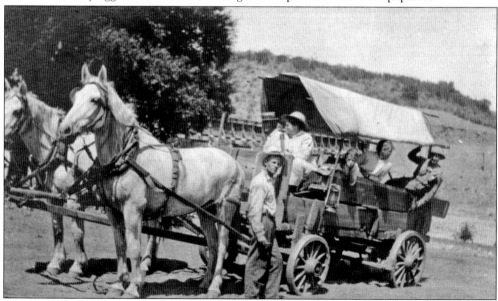

Camping, September 1916. The Alford and Gray families arrive at Barrett Dam, a popular site for camping, as were all sites related to water. The flume trestle is in the background.

CAMP FIRE GIRLS, 1915. Josephine and Lydia Burnell and their friend, Alice Sherrick, camp at Mesa Grande. Camp Fire Girls was organized in 1910 in Vermont. By 1913, there were 60,000 members nationwide. During World War I, the girls sold Liberty Bonds and Thrift Stamps, sewed clothes for French and Belgian orphans, and learned to garden and grow food. Native American culture inspired respect for nature.

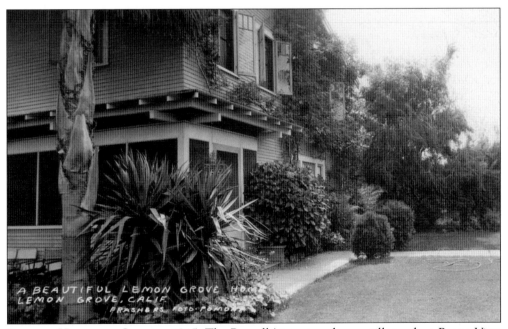

BURNELL HOME AND GARDEN, 1915. The Burnells' two-story home still stands at Buena Vista and Central Avenues. Barker and Julia Burnell arrived in Lemon Grove in 1907 and purchased from William Troxell a large tract on Central Avenue, where they built this home. Daughters Josephine and Lydia fulfilled their Camp Fire Girls goals to "seek beauty" and "give service" by planting the lovely garden seen here.

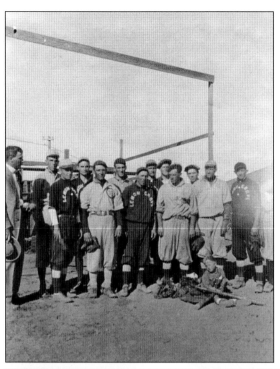

BASEBALL TEAM, 1916. The San Diego Baseball Association was formed in 1915. The Lemon Grove team was part of the Valley League. The team won the 1916 silver trophy etched with names of the sons of early pioneers: Near, Bumbaugh, Frazier, McCabe, Sonka, Fisher, Bell, Alford, and Morse.

SCHOOL BASEBALL TEAM, 1938. The grammar school had baseball, basketball, and football teams from its earliest days. Many of the boys seen here were sons of Anglo and Latino pioneers.

DENLINGER HAYRIDE, 1943. When he was not plowing and harvesting his own orchard, or hauling hay and hiring out his team to others, Walter Denlinger helped to direct Boy Scout troops and hold hayrides for local children. Edith Denlinger was PTA president for the local grammar school and Grossmont High School. Lemon Grove was the center of the Denlingers' world, and in turn, their ranch was a center for children's activities. Denlinger descendants still live near the original homestead. (Courtesy Denlinger family.)

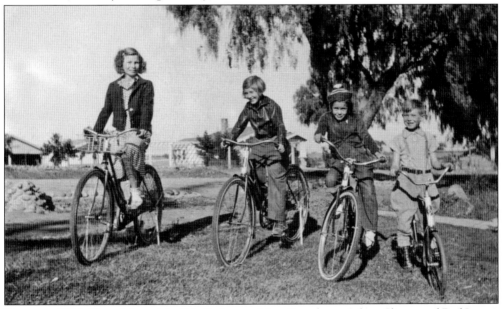

BICYCLES, 1936. From left to right, Marjie Jenner, Mary Stumborg, Arlene Sharp, and Bud Jenner were typical Lemon Grove kids; everyone had a bicycle to ride to the grammar school or on rambles around town and into the hills of nearby La Mesa. (Courtesy Mary Stumborg Martin.)

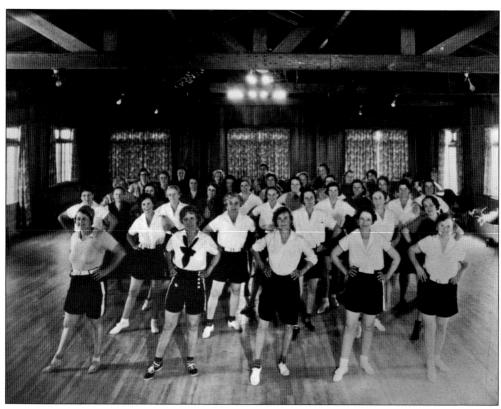

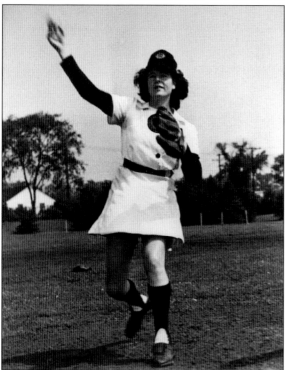

GYM CLASS, 1938. Gym members met in the Lemon Grove Women's Club on Olive Street for a weekly workout. The building, unchanged, is a hall at First Baptist Church of Lemon Grove. The club was founded in 1911 as the Forward Club to reflect its progressive, civic-minded outlook.

MARY MOORE, 1948. Mary Moore, a Lemon Grove native, was an equestrian and baseball star who pitched for the Rockford Peaches (featured in *A League of Their Own*). She grew up riding donkeys and horses on the Moore ranch on El Prado Avenue and pitching no-hitters against area school teams.

ADAN TREGANZA, 1938. Son of "The Big Lemon" architect, Alberto Treganza, Adan Treganza, right, became a noted anthropologist who founded the anthropology department and museum at San Francisco State University. In Jacumba, he unearthed an olla with "Happy, the Old Man of the Mountains," a well-known backcountry explorer. Adan's anthropological discoveries spanned the Southwest and northern Mexico.

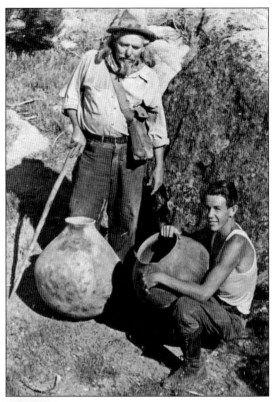

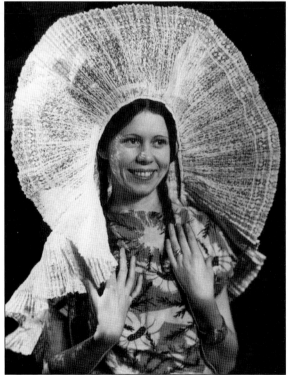

AMORITA TREGANZA, C. 1934. Interest in all forms of art flourished during the 1930s. The first Miss Lemon Grove and sister of Adan Treganza, Amorita Treganza was a commercial and artist's model, Spanish dancer, and a leading lady for a decade with the San Diego Community Theatre—the forerunner of the Old Globe Theatre in Balboa Park.

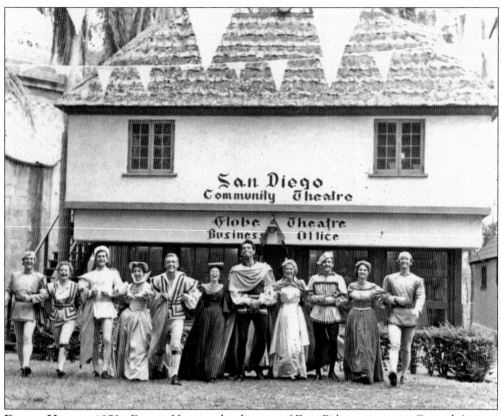

Dennis Hopper, 1952. Dennis Hopper, the director of *Easy Rider*, grew up on Central Avenue in Lemon Grove and performed with the San Diego Community Theatre at the Old Globe. Seen here fifth from left, he and fellow Helix High School graduate, Robert Turnbull, left for Hollywood together and found more than 15 minutes of fame. (Courtesy Special Collections and University Archives, San Diego State University.)

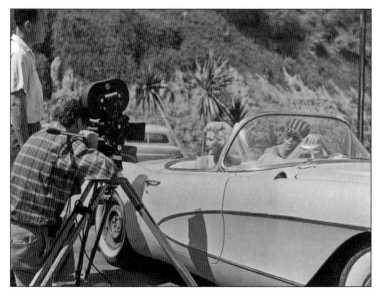

Robert Turnbull, 1956. Bob Turnbull is at the wheel of a Corvette in *Teenage Rumble*, one of many teen rebel movies popular in the 1950s. He began acting in high school and community theater and later forged a television and film career. He was the son of Old Globe pioneer, Amorita Treganza, and the grandson of "The Big Lemon" architect, Alberto Treganza.

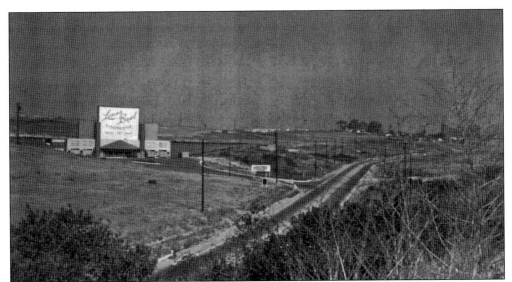

LEMON BOWL CINEMA-DINE, FEDERAL BOULEVARD, 1949. Ira Durham and Oliver McNeel ran Suburban Theatres, Inc., in Lemon Grove from 1949 to 1953. Patrons paid 25¢ to 50¢ and received two speakers, one for the movie and one for food orders. Carhops delivered food on little electric carts. Cinema-Dine opened with *Go for Broke*, a movie honoring the Japanese American heroes of the 442nd Regiment. The state bought the property for construction of Highway 94. Today the site holds a Toyota dealership. (Courtesy John S. Durham.)

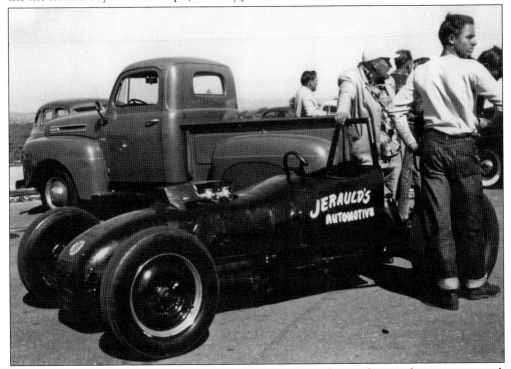

DRAG STRIP, 1950s. Sweetwater Road on the town's eastern border was the site of a civic-sanctioned, controlled drag strip for restless youth, who drove a variety of souped-up, exotically assembled, homemade vehicles. (Courtesy Thomas E. Clabby.)

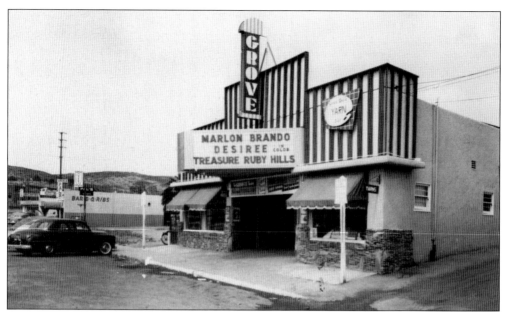

Grove Theatre, 1955. In those pre-multiplex days, Grove Theatre, the town's movie theater, ran A-list films. A 25¢ ticket bought a cartoon, newsreel, travelogue, previews, and the main feature. Another 50¢ netted popcorn and a candy bar.

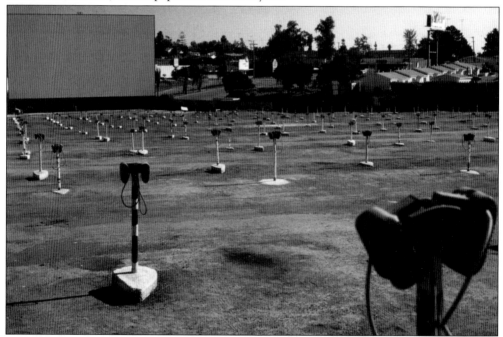

Ace Drive-In, 1983. The Ace Drive-In offered "B" movies at $1 per carload to families that thrilled to outer space, gangster, and Western films. The scent of onions and hamburgers grilling in the snack bar, the kids asleep in the back seat, and the huge screen against a starry sky left an indelible memory in the town psyche. By 1984, the rise of multiplexes and the need for more housing meant the demise of the iconic Ace. Today a condominium complex stands on the Grove Street site.

THE LEMON GROVE PLAYERS, 1980. The Lemon Grove Players performed in Lemon Grove Junior High School between 1977 and 1983. Shown is future mayor Robert Burns performing with Lacey Bowcock in the musical comedy *The Amorous Flea*. Volunteers produced, directed, acted, built sets, sewed impressive costumes, and sold tickets. Live musicians played at each performance, and tickets cost $1 to $3.

JACK OFIELD, 1995. Jack Ofield, the veteran film and television producer, stands on the set of *The Short List*, a long-running public television series. He divides his time between location filming, production and animation design in his Lemon Grove studio, and service as Filmmaker in Residence at San Diego State University. (Courtesy New Pacific Productions.)

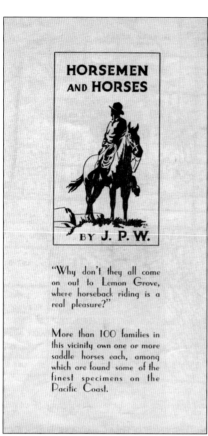

HORSEMEN AND HORSES, 1932. This Lemon Grove Chamber of Commerce brochure termed Lemon Grove "a paradise for saddle horse riding" in "a corner of Heaven" for "2,000 happy people." Many local families kept horses into the 1980s.

ST. JOHN OF THE CROSS CHURCH HORSE SHOW AND RODEO, 1944. Huge crowds ate barbecue and watched dressage, western, harness, polo, stunt-riding, calf-roping, and other events that drew national competitors and sponsors every year, from 1941 to 1957.

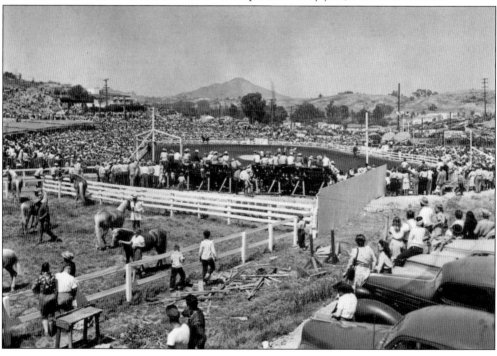

RODEO STARS, 1945. Msgr. Daniel O'Donoghue (left) welcomes Dale Evans, Roy Rogers, and Trigger to St. John's Rodeo. The monsignor developed the event to raise money for a new parish school built in 1948. Evans, Rogers, Trigger, Andy Devine, and the Sons of the Pioneer starred from 1945 to 1948.

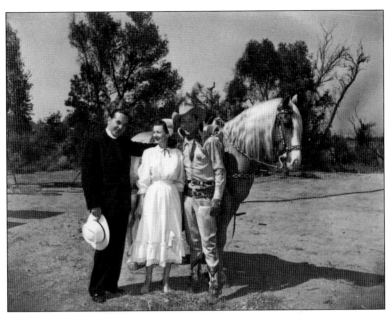

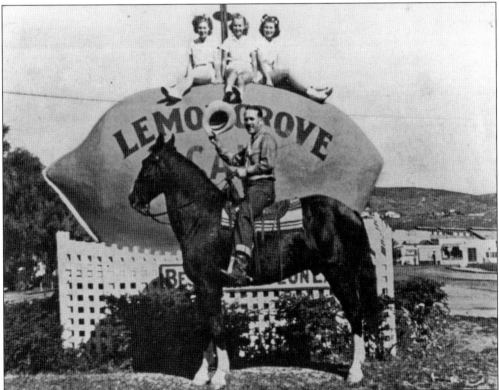

GERRY SMITH, 1953. Gerry Smith was a well-known Lemon Grove bronco rider who performed in the annual rodeo fund-raiser at St. John of the Cross Church, where he gave bone-rattling displays "aboard the hurricane deck of the wild Brahma bull descended from the sacred cattle of India and able to gore out the life of anyone who attempts to ride them," as one show program breathlessly explained.

ROMAN RIDING, 1942. The 11th U.S. Cavalry gave sensational Roman riding displays at St. John's Rodeo for a decade.

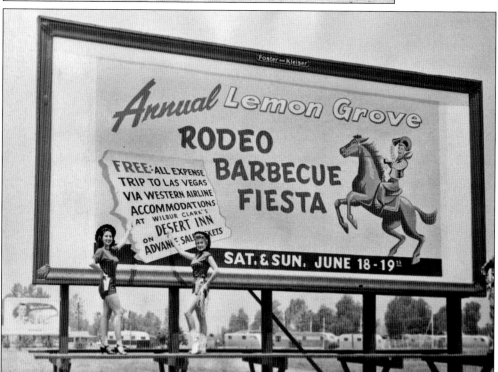

RODEO BILLBOARD, 1950. Over 16 years, nearly 100,000 people attended the St. John's and Lemon Grove Rodeos. The ties to the Hollywood and Las Vegas entertainment industries were the result of Monsignor O'Donoghue's entrepreneurial skills. This billboard featured a promotional link to the Desert Inn, which had just opened on April 24, 1950.

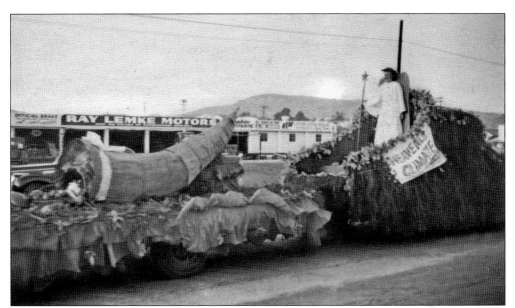

POW WOW DAYS, 1949. Created by the Business Women's League of Lemon Grove, this "Heavenly Climate" float won the Special Prize ribbon in the Pow Wow Days parade. Launched by local merchants early in the 1940s, this annual festival began as Appreciation Days, Pow Wow Days, Bargain Days, and Crazy Daze before becoming an homage to the town's pioneer past.

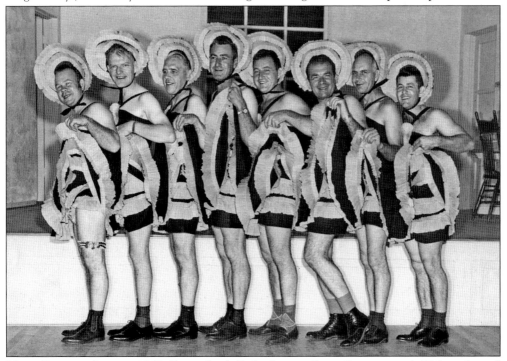

MALE CANCAN, AUGUST 1949. Dressed to kill, the Lemon Grove Businessmen's Club performed in the junior high school auditorium at a fund-raiser for Pow Wow Days. Local clubs sponsored many civic events. From left to right are Jim Snodgrass, Al Huebsch, Larry Hunter, Forest Baxter, Art Chappelle, Grant Hadley, Fred Michaels, and a lucky, unidentified man.

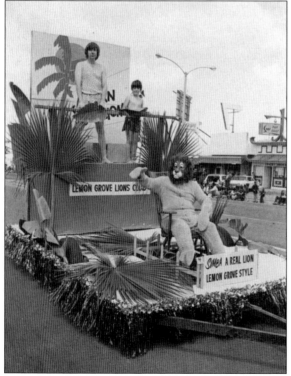

CRAZY DAZE, 1950s. Horses, prized by local residents, were a constant feature of the annual festival. In 1964, the event was dubbed Old Fashioned Days; in 1965, Old Tyme Days; and in 1966, Old Time Days. Parade meisters Dr. Sam Smith and Bob Mastney decreed "no political ads and never place marching bands behind horses."

LIONS CLUB FLOAT, 1970s. The Lemon Grove Lions Club float, replete with homemade costumes, was typical of the amusing displays that gave Old Time Days its folksy charm. Local service clubs like the Lions, Kiwanis, Rotary, and Soroptimist were important supporters of the parade and other civic activities.

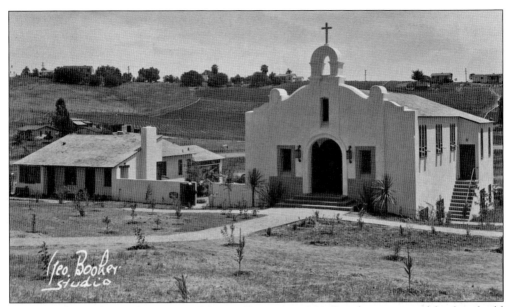

St. John of the Cross Church at Mission Rancho, 1940. Parishioners raised funds to build this mission-style church in 1940 on old Imperial Avenue. Formerly, services were held in a small house at 51 Lemon Avenue, where the pews were planks laid across fruit crates, the priests' robing room was a tiny closet, and holy water came from a kitchen next door.

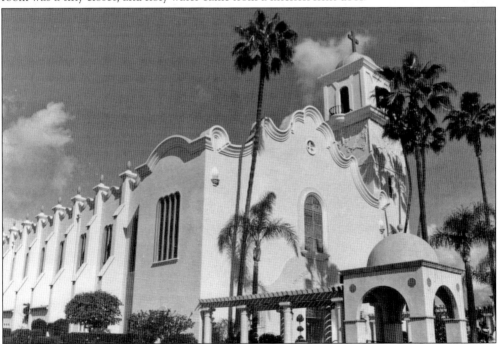

St. John of the Cross Church, 2002. As the population grew, parishioners raised funds to build this large Spanish Colonial–style church in 1958 opposite the original church, which now serves as the Knights of Columbus Hall. A recent fund drive expanded the parish school and built colonnaded rotundas. The city granted the church the former Christopher Columbus Way for use as a landscaped esplanade.

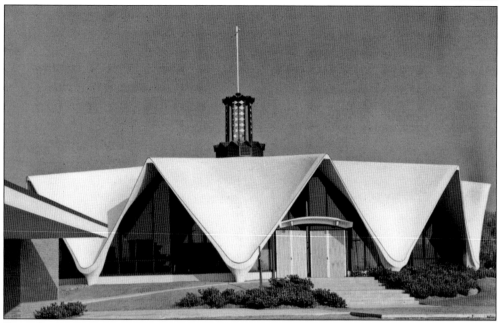

First Congregational United Church of Christ, 1962. The First Congregational United Church of Christ was the daughter church to the 1897 and 1913 congregational churches. Built for $300,000, it stands on Glebe Drive on 3.75 acres of a former vegetable truck farm. "Glebe" means "land belonging to a church." The roof represents a tabernacle or tent and features 12 flowing arches symbolizing the 12 disciples.

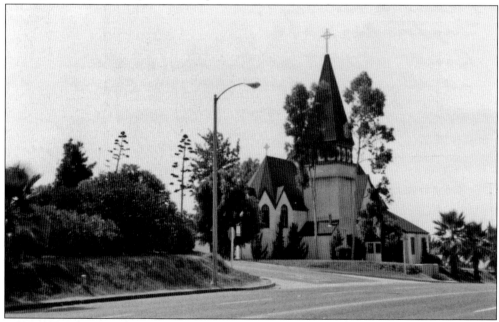

St. Philip the Apostle Church, 1970. This much-traveled church was built in 1887 in San Diego and moved three times before it came to rest at Palm Street and Hardy Drive in Lemon Grove in 1970. In 1972, a fire gutted it, but parishioners raised funds to restore its English Gothic beauty. Today it is the oldest continuously operated Episcopal church in the county.

Six

LEMON GROVE IN UNIFORM

SGT. JEROME T. WALTER, 1942. At 23, Walter served in the 976th Signal Corps as an instrument repairman, teletype operator, and cryptography installer in Africa, Corsica, and Italy. Despite its small size, Lemon Grove would send thousands of local men and women to serve in 20th and 21st century conflicts. The following pages show just a few.

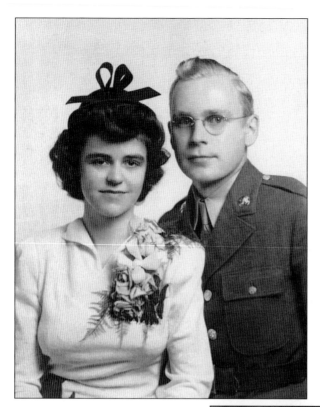

JEROME AND JEANNE WALTER, DECEMBER 1, 1942. Jerome and Jeanne Walter were among thousands of war recruits who married, then were transferred to the West Coast, where they fell in love with Lemon Grove and stayed for life. An expert watchmaker, Jerome ran Walter's Jewelers on Broadway from 1949 to 2008.

LAWRENCE AND BETTY HUNTER, DECEMBER 1, 1941. Seen one month after their marriage, Lawrence Hunter served in the U.S. Army as a staff sergeant in England and France from 1942 to 1944. He returned to run Hunter's Nursery. Betty Hunter and her son, Guy, run the nursery today, and fourth generation Hunters are ready to assume leadership of this landmark 1919 business.

ROBERT AND JACQUELYN BURNS, 1943. Robert Burns was a Marine Corps medic, and Jacquelyn Burns was a nurse cadet when they married in 1946. The Michigan natives settled in Lemon Grove in 1955. Robert was Lemon Grove's veterinarian, city councilmember, and mayor who fought for civic incorporation. Dr. Burns left a legacy of development, philanthropy, and volunteerism.

CHARLES AND BARBARA RODEFER, 1944. High school sweethearts Charles and Barbara Rodefer were married while he was on furlough from the navy. At the war's end, they came home to Lemon Grove.

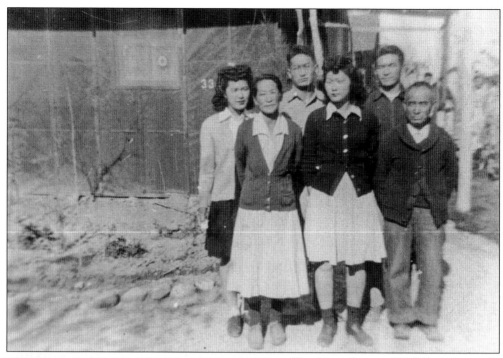

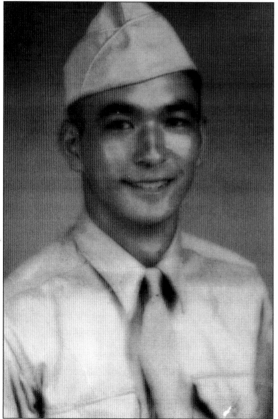

THE KIDA FAMILY, 1942. Jizaemon and Chitsue Kida arrived in East County in 1915 to begin a lifetime of farming. After the bombing of Pearl Harbor on December 7, 1941, Japanese American citizens were viewed as potential spies and saboteurs and sent to internment camps. The Kidas were sent to Poston, Arizona, and assigned this tar-papered unit, No. 33. From left to right are (first row) Chitsue, Fusae, and Jizaemon Kida; (second row) Hesae, Tom, and Satoshi.

CPL. SATOSHI KIDA, U.S. ARMY, 1944. While at Poston, Kida volunteered for the army but was rejected due to a bronchial infection. Soon after he was drafted and served for two years in Italy in the legendary all-Japaanese 442nd Regiment. He was a varsity quarterback at Grossmont High School, class of 1940. In 1945, he married Momoye Oyama, whom he met at Poston.

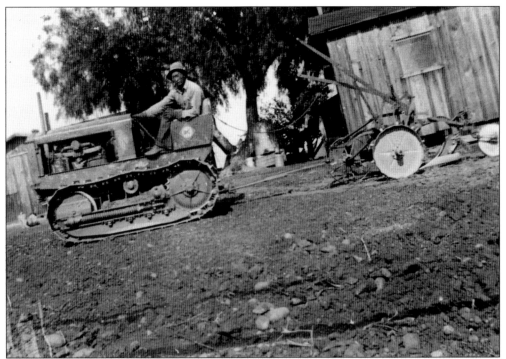

TOM KIDA, EARLY 1950s. After the war, the Kidas returned to Lemon Grove. Tom is seen plowing their tomato field on Berry Street. Their property was not lost to the Alien Land Law or to vandalism and theft but was defended by the parishioners and the Sunday School teacher, Mrs. Flagg, of the First Congregational Church of Lemon Grove. Kida descendants live on the property today. (Courtesy Japanese American Historical Society of San Diego.)

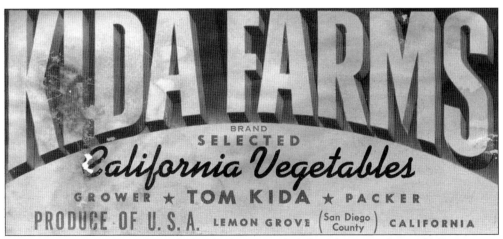

KIDA LUG LABEL, 1951. The Kida family also expanded their farm into Spring Valley to grow strawberries, Italian squash, and other truck vegetables. (Courtesy Japanese American Historical Society of San Diego.)

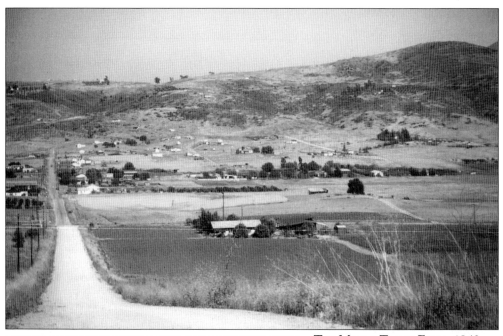

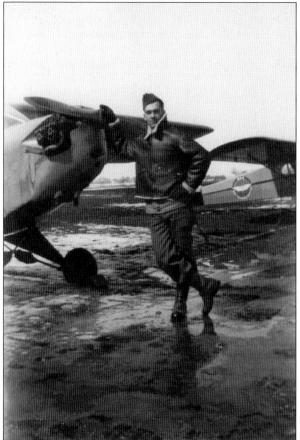

THE MUKAI TRUCK FARM, 1943.
Tasaburo and Fusae Mukai ran a
50-acre fruit and vegetable farm
on Lemon Grove's eastern border.
While the family was imprisoned
at Poston during the war, their
employees protected the farm.
Ironically, Tasaburo was hired as
an interpreter during America's
postwar occupation of Japan.
Sons Tom and Abe continued
farming until 1968 when the
State of California took the
land under eminent domain for
construction of State Route 125.
(Courtesy Hunter's Nursery.)

**SGT. RENÉ COLLETTE, U.S. ARMY
AIR FORCE.** Collette served from
1943 to 1945 as a cryptographer,
cracking codes in India, China,
and Burma. He married Lillian
Sando in 1947 in San Diego
and moved to Lemon Grove
in 1950, where they bought
their first home. At Convair,
he supervised the Engineering
Department. Here he stands next
to a Piper Cub in Minnesota.

Comdr. John Daniels, U.S. Navy, 1942–1967. Daniels stands at left in the second row. He was the pilot for carrier fighters USS *Essex* and USS *Bon Homme Richard*, and received the Air Medal for 1,000 safe landings. Back home in Lemon Grove, he and Elizabeth Daniels raised nine children in their Monterey Revival home, designed by Frank L. Hope, on Golden Avenue.

Radioman, Second Class John Durham, U.S. Navy Squadron 83, 1944. Durham stands second from right, third row, at the naval airbase, Oahu, Hawaii. He enlisted at 17 as a radio operator on the Grumman TBM Avenger at left and survived several sea battles. He was shot down during the Battle of Iwo Jima and received the Purple Heart. He married Margaret McKinnie and ran Durham Insurance Agency in Lemon Grove from 1946 to 1983.

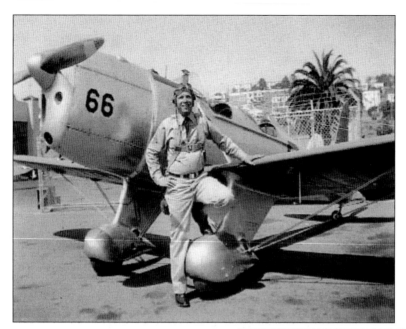

LT. COL. RALPH MILLER, U.S. ARMY AIR CORPS, 1940. Miller flew B-17 and B-24 bombers in the South Pacific, Europe, and Southeast Asian theatres. Here he stands next to a trainer plane at Lindbergh Field.

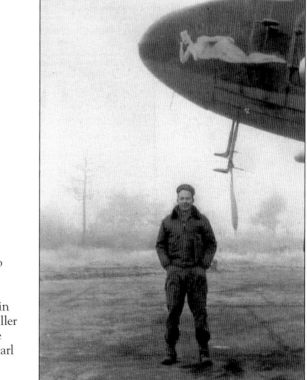

CPL. WILLIAM MILLER, U.S. ARMY AIR CORPS, 1944. Miller was a radio operator on C47s, dropping supplies to allied troops during the Battle of Bulge. He stands next to "Queenie" in England. He was milking cows at Miller Dairy on December 7, 1941, when he heard the news of the bombing of Pearl Harbor on the barn radio and asked, "Where the hell is Pearl Harbor?"

REAR ADM. IRA D. PUTNAM AND ROSEMARY PUTNAM, 1988. The Putnams were childhood sweethearts and San Diego State College graduates, who married in 1942. He survived Pearl Harbor and the Battle of Midway and rose from ensign to rear admiral over a 34-year naval career. She has led the Friends of the Lemon Grove Library for nearly 30 years while serving in other local service clubs. (Courtesy Rosemary Putnam.)

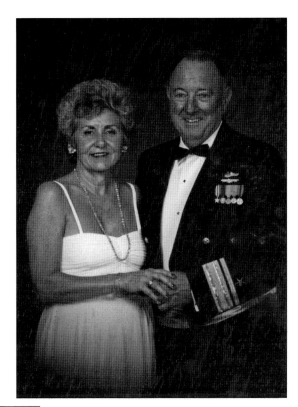

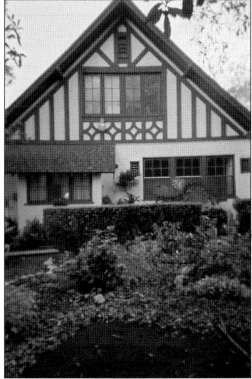

THE SIMPSON HOUSE, 1926. Ira and Rosemary Putnam raised four daughters in this Tudor Revival house, which flourishes today. It was designed by British architect Frederick Clemeshaw for his colleague, George Simpson, a Scottish builder, in the half-timbered English style so popular during the American country home movement of the 1920s.

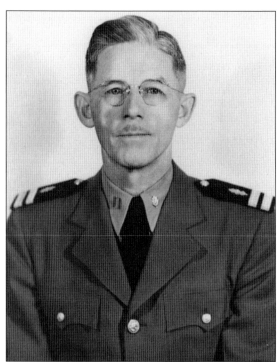

DR. EBON McGREGOR, 1943.
Lemon Grove's doctor from 1928 to 1943, McGregor pioneered the use of the Wasserman blood test and supervised care of combat veterans in Washington, D.C., during the Roosevelt years. Backed by Upton Sinclair, he twice ran for state office on a New Deal ticket but lost. During the Depression, he said to Tony Sonka (about Lemon Grovians), "You keep them fed, and I'll keep them alive."

THE McGREGOR HOUSE, 1936. Alberto Treganza designed this solar-powered, Spanish Revival home and medical office for Dr. McGregor in 1932. The house was built over a four-year period by the sweat equity of patients unable to pay medical bills during the Great Depression. This unusual approach made headlines and resulted in a handsome residence, which survives today on Main Street.

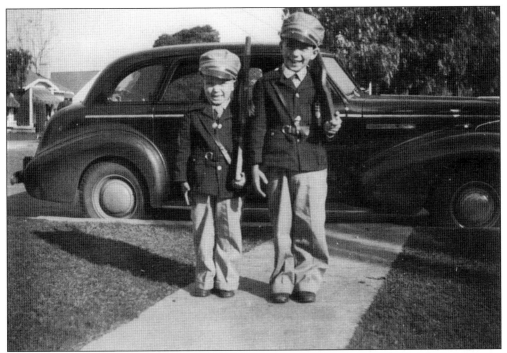

Little Soldiers, 1940s. From left to right, Billy and Johnny Elkins, grandsons of Lemon Grove pioneers Pher and Anna Johnson, parade on the sidewalk. Their uncle, Oscar Johnson, was a decorated pilot during the war.

Children's Victory Parade, 1945. Lemon Grove schoolchildren paraded on their bicycles to celebrate the end of World War II. Most had parents and relatives involved in the war effort.

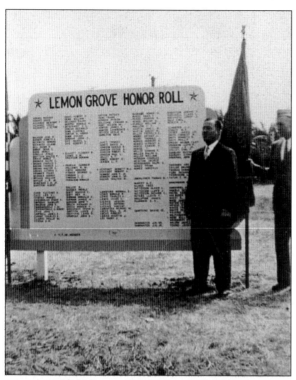

LEMON GROVE HONOR ROLL, 1945.
The Honor Roll listed all Lemon
Grovians who served in World
War II. The roll stood by "The
Big Lemon" throughout the war
and was maintained by the First
Congregational Church of Lemon
Grove. The names represented
every ethnic group in town.

**CHIEF ELECTRICIANS MATE DELL
LAKE, U.S. NAVY, 1947.** Lake stands
at left aboard the USS *Paiute* in the
Bahamas. He arrived at Pearl Harbor
on Christmas Eve 1941, to spend two
years pulling up sunken vessels for
salvage. He served in the navy from
the South Pacific to the Arctic Circle
until 1958. He and his wife, Stella,
bought their Lemon Grove home in
1948. They helped to incorporate
Lemon Grove in 1977, and he served
on the first city council from 1977
to 1985. (Courtesy Dell Lake.)

PFC. THOMAS E. CLABBY, U.S. ARMY, GERMANY, 1953. Standing at right, Clabby served in the Army of Occupation during the cold war with the 35th Transport Company. He and his wife, Dona, built their Lemon Grove home on the GI Bill and raised three children. He was a contract manager for Rohr Industries and a city councilmember for 14 years. (Courtesy Clabby family.)

CASTELLANOS-OYOS WEDDING, 1954. Robert Castellanos, the son of Tiburcio and Refugio Castellanos, who settled in Lemon Grove in the 1920s, was a telephone pole lineman during the Korean War. Right after the war, he married his childhood sweetheart, Lorraine Oyos, in St. John of the Cross Church. (Courtesy John Castellanos.)

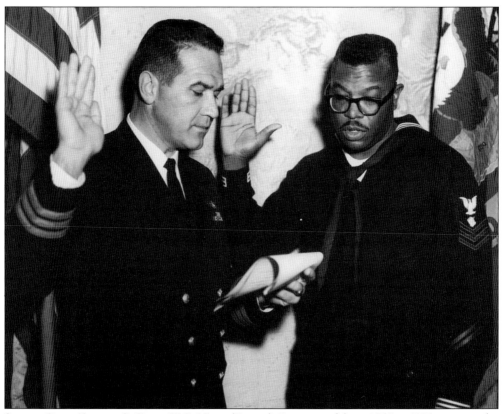

SENIOR CHIEF ERNEST G. PERO, U.S. NAVY (RIGHT). Pero served from 1956 to 1975, earning the Navy Achievement Medal in 1971. He was on Bikini Atoll for the atomic bomb test in 1958. In 1968, he assisted the survivors of the USS *Pueblo* incident, following their release from a North Korean prison. He is seen in 1967 re-enlisting for duty in Vietnam aboard the USS *Constellation*. He has run a real estate company in town for over 30 years.

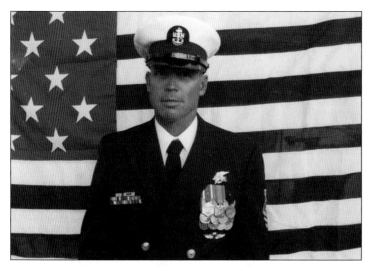

CPO PAUL W. ANDERSON, NAVY SEAL. A 22-year veteran whose first boss was Pres. Ronald Reagan, Anderson served in Just Cause in Panama, Desert Shield and Desert Storm in Iraq, and the global war on terror in the Middle East and Asia. Today the Lemon Grove resident trains Navy Seals. (Courtesy Susan R. Brandt.)

Seven

THE BUSTLING
COMMUNITY

BROADWAY, 1955. Looking east on Broadway, the profusion of cars, signs, and shops embodied the postwar industry and energy that changed Lemon Grove from a whistle-stop, agricultural town into a bustling, modern community with pretty neighborhoods and excellent schools.

STATE ROUTE 94, 1956. This was the view of the new freeway, looking west from the Broadway on-ramp. The freeway both changed and challenged the town by bringing new residents and businesses, along with competition from freeway-oriented developments in adjacent cities.

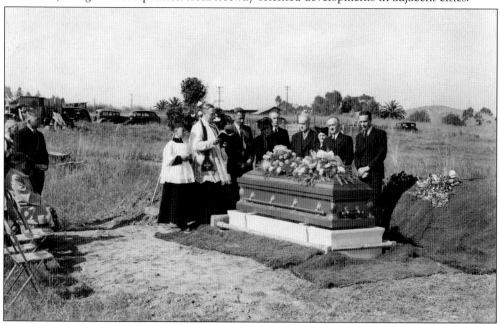

FUNERAL OF POLISH PRINCESS, APRIL 19, 1941. When the Polish peerage was displaced by Nazis and Russians, some were sent to the Siberian Gulag to work in the coal mines. In 1939, Princess Filomena Wojciechowski Sledzinski and her husband, John Sledzinski, fled to Lemon Grove, where they bought a home on 6 acres at 6810 Broadway near College Avenue. She was buried by her home, but when the site became the on-ramp to State Route 94, she was moved to Greenwood Cemetery.

ALBERTO OWEN TREGANZA, AIA, 1940. Architect, artist, and furniture designer Alberto Owen Treganza ran his practice in the Treganza family compound—which still stands—until his death in 1948. He restored the Spanish Village in Balboa Park for the 1935 exposition, codesigned San Diego's first police headquarters (now a national historic site), and left a legacy of Spanish-style homes countywide. His lasting monument may be "The Big Lemon."

EDMUND J. DUNN, MID-1950S. From 1922, Edmund J. Dunn and his wife, Gladys, ran a citrus orchard, now operated by their grandson's family. Edmund was a noted builder whose English cottage-style home and office still stand. He worked with architects Alberto Treganza, Lloyd Ruocco, and others to construct homes and buildings throughout the county. Here he (center) reviews construction plans for a building in La Mesa. (Courtesy Dunn-Brandt family.)

POST OFFICE, 1945. This post office on Main Street succeeded the original one inside the Sonka store. Lemon Grove was two words from 1893 to 1895. The U.S. Postal Service made it "Lemongrove" from September 5, 1895 to June 22, 1950, when the name reverted to two words. Residents mostly ignored the one-word version and used "Lemon Grove" in their correspondence and business records. The original 92045 zip code arrived in 1963.

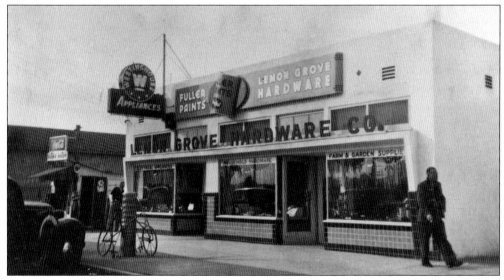

LEMON GROVE HARDWARE, 1945. Tony Sonka felt that no growing town was complete without a good hardware store, so he built this one on the site of the old Kleinfeld house on Pacific Street. John Sanders ran the hardware store until 1962 when he died. His wife, Elza Sanders, ran it until 1966. Today a gift shop stands on the site.

DASSAH NEWTON, 1945. Dassah Newton was related to the Sonka family and representative of the pioneer families whose descendants live on in the town and environs today. Her Central Avenue home still stands. Her kitchen featured items purchased at the Sonka Brothers Store and Lemon Grove Hardware, along with eggs, produce, dairy products, and chickens from local farms. She made her own pot holders, aprons, and flour-sack tea towels.

LEMON GROVE LIBRARY, 1947. The town's first library was a literal shelf on a state-owned wagon in 1906. In 1942, Tony Sonka provided a room in his new drugstore, shown here, at Golden and Imperial Avenues for $20 per month. In 1958, Ira Durham, a local insurance agent, built a new library on Pacific Street and leased it to the county. In 1979, the present, busy library was established in a strip mall on Broadway. A new joint-use library will be built in the near future by the school district.

CASEY'S SEPTIC TANK. This company spanned the town's pioneer days into the 1970s. Until the mid-20th century, residents relied on wells, cisterns, and septic fields. Casey pumped out such systems, on average, twice annually. In the 1960s and 1970s, local children called the newfangled portable toilets "Casey Rentals."

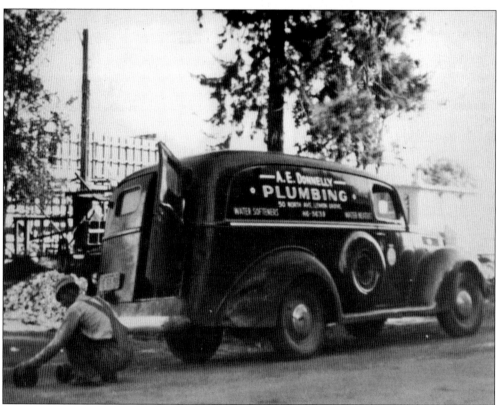

FIRST SEWER LINE, 1947. By 1947, the town had about 5,000 residents, but no sewer line. The state advanced $19,980 for a $90,000 trunk line connecting the town to the main line in Encanto. After Tony Sonka raised about $65,000 from property owners, he obtained the balance through a bank loan. Here Lemon Grove plumber A. E. Donnelly hooks up the first sewer line connection near present-day Por Favor Restaurant on Lemon Grove Avenue.

TREE PLANTING, 1952. The Business Women's League, seeking to beautify the railroad right-of-way, planted a live Deodar cedar to serve as a permanent Christmas tree at Broadway and Imperial Avenue. The tree, along with a nativity scene, remained for more than a decade until road widening and disputes over civic-sanctioned Christmas decorations eliminated it.

CHRISTMAS, 1953. In the shadow of the permanent Christmas tree, in the "Best Climate on Earth," little Maureen McCormick stands next to an unusual friend. In the background at left is the Lemon Grove Lumber Company tower holding the fire alarm siren.

FIRE DEPARTMENT, 1956. The town struggled with fire protection for decades, often relying on the Forestry Service. In the early 1960s, this small fire hall received a $25,000 remodel, including a second floor with a traditional pole so that firemen could slide down. The hose drying tower rises at rear. Here firemen pose proudly with new trucks and service vehicles.

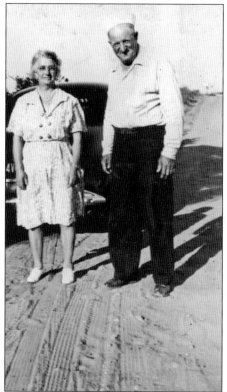

WALTER AND EDITH DENLINGER, 1946. After a lifetime of working their land, Walter and Edith Denlinger witnessed the demise of the old agrarian patterns as thousands of lemon trees were cut down in the 1950s to make way for homes. Rather than see all of their land become a suburb, in the 1960s, these visionaries donated acreage for the town's first public park on Washington Street. Dubbed "Green Spot Park," it was later renamed Lemon Grove Park and includes facilities for all ages. They also donated land for the Lemon Grove United Methodist Church. (Courtesy Denlinger family.)

GEORGE D. CREMER (1917–2008).
Aerospace pioneer George D. Cremer was a gymnast while attending Massachusetts Institute of Technology in 1937. He served the Manhattan Project, Oak Ridge National Laboratory, the U.S. Department of Energy, and Solar Aircraft Company (Solar Turbines) in San Diego. He developed products and fabrication techniques for the Saturn and Apollo spacecraft and the first jet engines and afterburners. The Cremers lived for 50 years in the Tudor Revival H. Lee House in Lemon Grove.

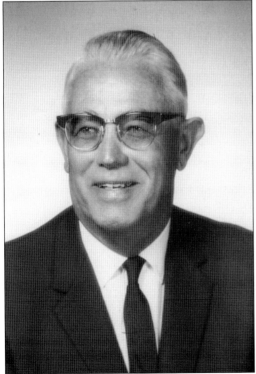

HARRY GRIFFEN, HELIX IRRIGATION DISTRICT, 1970s. Harry Griffen led the district as a board member and as director from 1951 to 1978, and was instrumental in improving the quantity and quality of water in the region. He fostered the policies of the modern Helix Water District. An ardent water conservationist and gardener, he sought the Mukai family's advice for growing celery and other crops around his Lemon Grove home, still flourishing under family ownership.

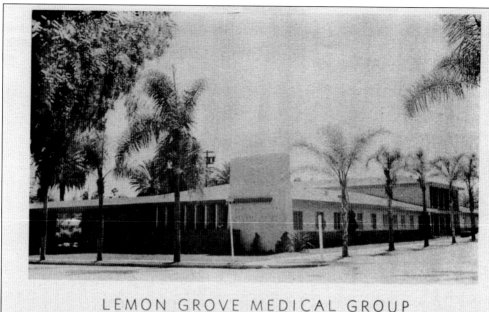

LEMON GROVE MEDICAL GROUP
Corner of Main and Daytona Streets, 3240 Main Street, Lemon Grove, California
Day or Night Phone 463-9201

LEMON GROVE MEDICAL GROUP, 1957. Built by Drs. Simon Brumbaugh and Wesley Herbert on Main Street, the building is now Lemon Grove City Hall. The medical group included 13 doctors, two radiologists, and administrative staff. Ten doctors were general practitioners; one handled general surgery; another, ophthalmology; and another, obstetrics and gynecology. (Courtesy Dr. Simon Brumbaugh.)

DR. AMORITA TREGANZA, 1970S. Dr. Amorita Treganza was a pioneering children's eye doctor and the first woman to head a national medical organization, the College of Optometrists and Vision Development. She had offices in Lemon Grove and San Diego and devised diagnostic tools, exercises, and lenses for children with eye problems. During the Depression, she worked in the fruit packinghouse to help her family.

Eight

THE CITY PROUD

ITS TIME HAS
COME, JULY
1, 1977. This
triumphant phrase
proclaimed the
birth of California's
414th incorporated
city. With adjacent
cities annexing
parts of its territory
and feeling like a
neglected stepchild
unable to garner
adequate county
funding for parks,
road repair, and
other necessities,
the town mounted
four elections and
won on the fourth
try despite rising
taxes. Now the
town would chart
its own destiny,
come what may.

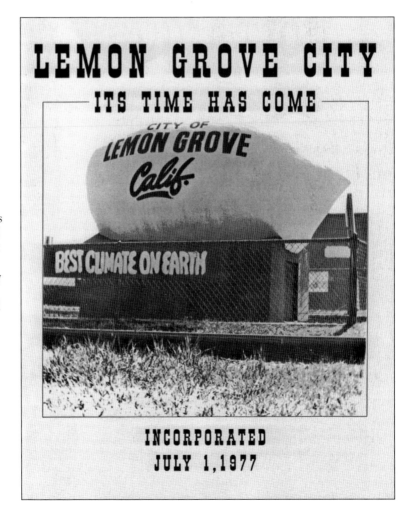

FIRST CITY COUNCIL, 1977. From left to right, new councilmembers Dr. Robert Burns, Dale Bailey, Dell Lake, and Jack Doherty beamed as county supervisor Lucille Moore presented new Mayor James V. Dorman with a congratulatory proclamation. The council joined the 13 other incorporated county cities in area-wide planning and provided for sales tax, law enforcement, city staff, a city seal, and other official needs.

FIRE DEPARTMENT, 1977. Under Fire Chief Robert Adams, there were 19 firemen housed in a $1.2 million headquarters on the site of their old firehouse on Central Avenue. The facility was financed through federal revenue sharing and the young city's capital improvement fund. The Lemon Grove Fire District became the San Miguel Fire Protection District from 1997 to 2004, and then reverted to its historical name, the Lemon Grove Fire Department.

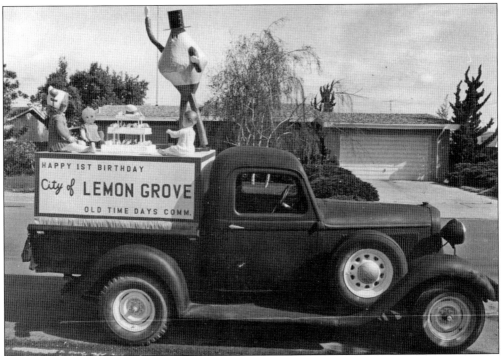

CITY'S FIRST BIRTHDAY, 1978. The Old Time Days parade featured the city's dapper mascot, Mr. Lem N. Grove, who was "born" in 1972 and forever after received mail urging him to invest in silver mines, buy vacation packages, purchase new cars, and gamble in Las Vegas.

MOVING INTO CITY HALL, 1980. The 1957 Lemon Grove Medical Group building became the joint city hall-sheriff facility at 3232 Main Street. Today the city campus includes the Community Services building, Civic Center Park, the H. Lee House Cultural Center, and the Parsonage Museum. (Courtesy Dell Lake.)

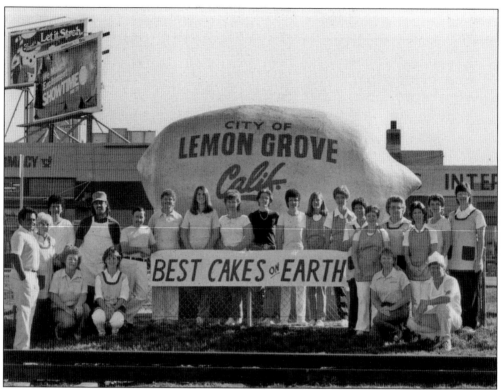

BEST CAKES ON EARTH, 1981. In 1955, the Swedish Ohlund family started Grove Pastry Shop with their legendary whipped-cream cakes. In 1980, they moved from Broadway into the former Sonka Brothers' General Store at Main and Pacific Streets. The building is now the oldest, continuously operated, commercial structure in Lemon Grove. Lennart Ohlund kneels at right, and Maria Ohlund is second from left. Today the business is run by Teresa Johnson.

THE FOOD FACTORY, 2009. Since 1973, the Food Factory has been the indispensable center for political campaigns (the city's incorporation efforts percolated here), local gossip, and home-style food like the World War II–era "S.O.S." (creamed hamburger on toast), Bob Bailey's Country Western Burger Special, and Lori Bailey's fresh soups and pies. Lori is John Durham's daughter of the longtime local business family. The place began as Mel's Root Beer in the 1940s before becoming the most popular lunch counter in town. (Courtesy Bailey family.)

LOIS HEISERMAN, 1980. Lois Heiserman was the first woman to serve on the city council and as vice mayor. With Ruth Pfister, she led the development of the Senior Meals Program. The Lemon Grove Senior Center in Lemon Grove Park is dedicated to her memory. The building was a major effort by the city to serve the needs of a population that is living longer and comprises a fourth of local residents. (Courtesy Heiserman family.)

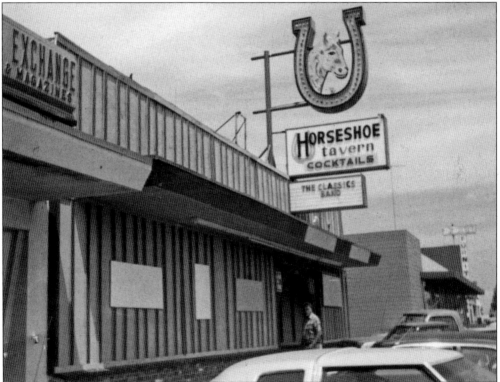

HORSESHOE TAVERN, 1980s. In a town that loves horses and civic folk art, the horse head in a horseshoe atop the Horseshoe Tavern was a landmark until a 1990 ordinance outlawed roof-mounted signs. As a result, "Rex" rode off into the sunset, leaving the bistro bereft of its pioneer connection, if not of its loyal patrons. The horseshoe, resplendent with lights, was mounted on the dance floor ceiling by Dirk Westerhout, who bought the place in 1986. He named it Dirk's Horseshoe Lounge, then Dirk's Niteclub. (Courtesy Dirk Westerhout.)

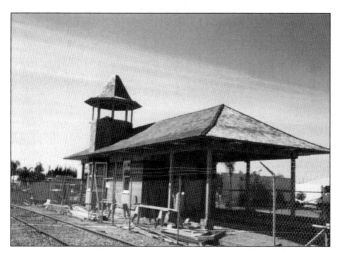

BUILDING THE TROLLEY STATION, 1986. The trolley follows the original 19th-century railroad track but stops at a re-created station, fostered by former mayor Robert Burns and the first city manager Jack Shelver. The Victorian cupola caps one of the prettiest stations in the county and is featured on the city's logo. Transit-oriented, energy-efficient housing, flanked by park and pedestrian areas, will be built in the near future.

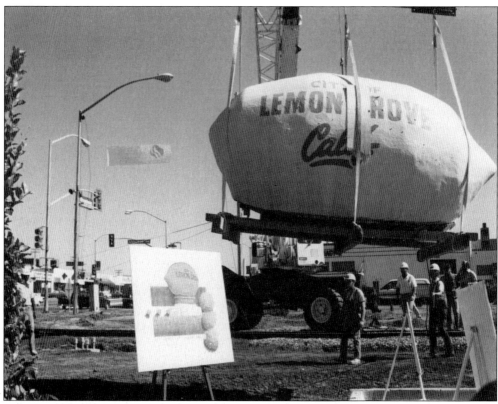

MOVING "THE BIG LEMON", 1986. The 3,000-pound lemon was hoisted on pulleys and moved a few feet east of its traditional location to make way for an extra track that allowed northbound and southbound trolleys to pass each other. The lemon was then reset on its plinth, and civic leaders rested easy once more after a heart-stopping morning.

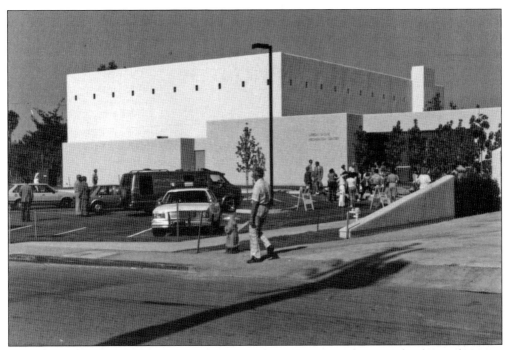

RECREATION CENTER, 1984. The city built this large, busy complex on School Lane between adjoining school campuses to serve people of all ages year-round. (Courtesy Dell Lake.)

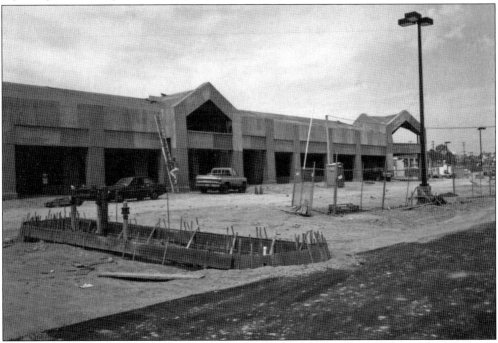

LEMON GROVE PLAZA, MAY 1989. Seen under construction on Broadway, this was the city's first major shopping plaza. It was a project of the Lemon Grove Redevelopment Agency and gave the city a competitive edge against similar plazas in adjacent communities. (Courtesy City of Lemon Grove.)

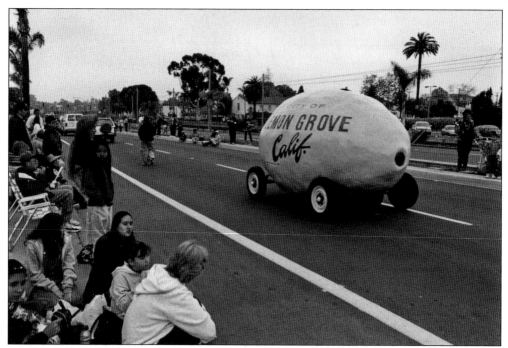

THE MOBILE LEMON, 1993. A Pasadena float company built the mobile lemon in 1978 for a Honda television commercial that advised people not to buy a "lemon." The City of Lemon Grove bought it to use in Old Time Days parades. Local volunteers motorized, painted, and re-lettered the "Little Lemon."

RETIRED VOLUNTEER SENIOR PATROL (RVSP) CARTOON, 1994. Comprised of 150 trained retirees, the RVSP functions as "eyes and ears" for the sheriff by ticketing illegal parking in handicapped zones and providing crowd and traffic control and vacation and shut-in checkups. This affectionate send-up by the city's resident cartoonist, E. M. Martin, depicts former Lemon Grove mayor, the late Dr. Robert Burns, who, like Martin, was a founding member of the RVSP. (Courtesy E. M. Martin.)

SAVING THE CITY'S FIRST CHURCH, 1998. One hundred years after the First Congregational Church was built in 1897, the Lemon Grove Historical Society rehabilitated it as the Parsonage Museum of Lemon Grove. Project director Helen Ofield (left) and foreman Gary Elbert (right) led teams of local volunteers and AmeriCorps students in a two-year effort. The museum opened on September 26, 1999. The historical society received a 2001 Governor's Historic Preservation Award for the project.

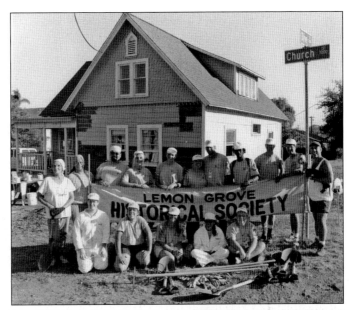

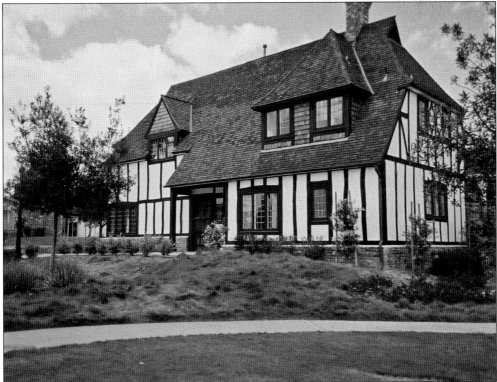

SAVING THE H. LEE HOUSE, 2006. The 1928 Tudor Revival, designed by Frederick Clemeshaw, stood in the path of the extension of State Route 125. The dramatic rescue on July 12, 2002, by the city, CalTrans, the Metropolitan Transit Authority, and the historical society entailed towing the house across town and over the trolley tracks to Civic Center Park to become the city's cultural center. The city reclaimed its past by building the park on the town's original footprint, where the first church, train depot, packinghouse, and "Castle" schoolhouse once stood.

DCH Honda Groundbreaking, January 2007. The huge Honda dealership, with its green-hybrid cars, has risen on land formerly occupied by a fruit packinghouse and stable. Councilmembers Mary England (third from left), Tom Clabby (center, white shirt), and Jerry Jones (second from right) participated in the ceremonial groundbreaking with dealership manager Gary Sorter. (Courtesy City of Lemon Grove.)

The Green Revolution, 2009. The city is home to EDCO Disposal Corporation, the largest family-owned waste and recycling company in California. Founded in 1967 and a leader in the green revolution, EDCO accelerated its innovative recycling technologies when the state adopted AB 393, requiring municipalities to divert at least 50 percent of their waste by the year 2000. EDCO is one of a handful of facilities that recycles construction debris for use in other products worldwide. (Courtesy EDCO Disposal Corporation.)

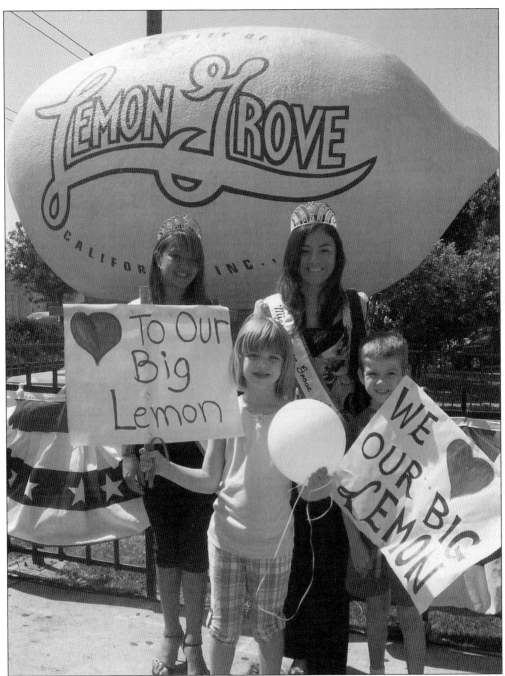

"THE BIG LEMON'S" 80TH BIRTHDAY (OBSERVED), JULY 3, 2008. On the 80th birthday of "The Big Lemon," 80 children released 80 balloons while singing "Happy Birthday, Dear Big Lemon;" dignitaries read proclamations; and Gizeth Saucedo (right), the 80th Miss Lemon Grove, and Cassandra Johnson, Miss Teen Lemon Grove, welcomed throngs of applauding, cheering residents as television cameras rolled. Century-old lemon trees still dot the town and "The Big Lemon" still stands sentinel by the trolley tracks, proclaiming the town's noble agrarian past. Oh, Lemon Grove, live!

www.arcadiapublishing.com

Discover books about the town where you grew up, the cities where your friends and families live, the town where your parents met, or even that retirement spot you've been dreaming about. Our Web site provides history lovers with exclusive deals, advanced notification about new titles, e-mail alerts of author events, and much more.

MADE IN THE USA

Arcadia Publishing, the leading local history publisher in the United States, is committed to making history accessible and meaningful through publishing books that celebrate and preserve the heritage of America's people and places. Consistent with our mission to preserve history on a local level, this book was printed in South Carolina on American-made paper and manufactured entirely in the United States.

This book carries the accredited Forest Stewardship Council (FSC) label and is printed on 100 percent FSC-certified paper. Products carrying the FSC label are independently certified to assure consumers that they come from forests that are managed to meet the social, economic, and ecological needs of present and future generations.

FSC
Mixed Sources
Product group from well-managed forests and other controlled sources

Cert no. SW-COC-001530
www.fsc.org
© 1996 Forest Stewardship Council

Find Your Place in History.